COLORING BOOK

BEAUTIFUL WOMEN PORTRAITS

KREATIF LOUNGE

THIS BOOK BELONGS TO

KREATIF LOUNGE

COLORING TIPS

We have printed the art in single-sided pages. Each image is placed on its own black-backed page to reduce the bleed-through to the next image. If you are using markers, it strongly recommended sliding a piece of cardstock or thick paper behind the page you are working on to make sure the ink doesn't stain the next page.

We provided double images that placed in version 1 and version 2. Therefore, you will be able to color your favourite art twice in case you want to have a different version of each artwork.

Now relax enjoy "ME" time :)

KREATIF LOUNGE

KREATIF LOUNGE
©2019 KreatifLounge. All rights reserved
Contact: kl@blondea.com

VERSION 1

KREATIF LOUNGE

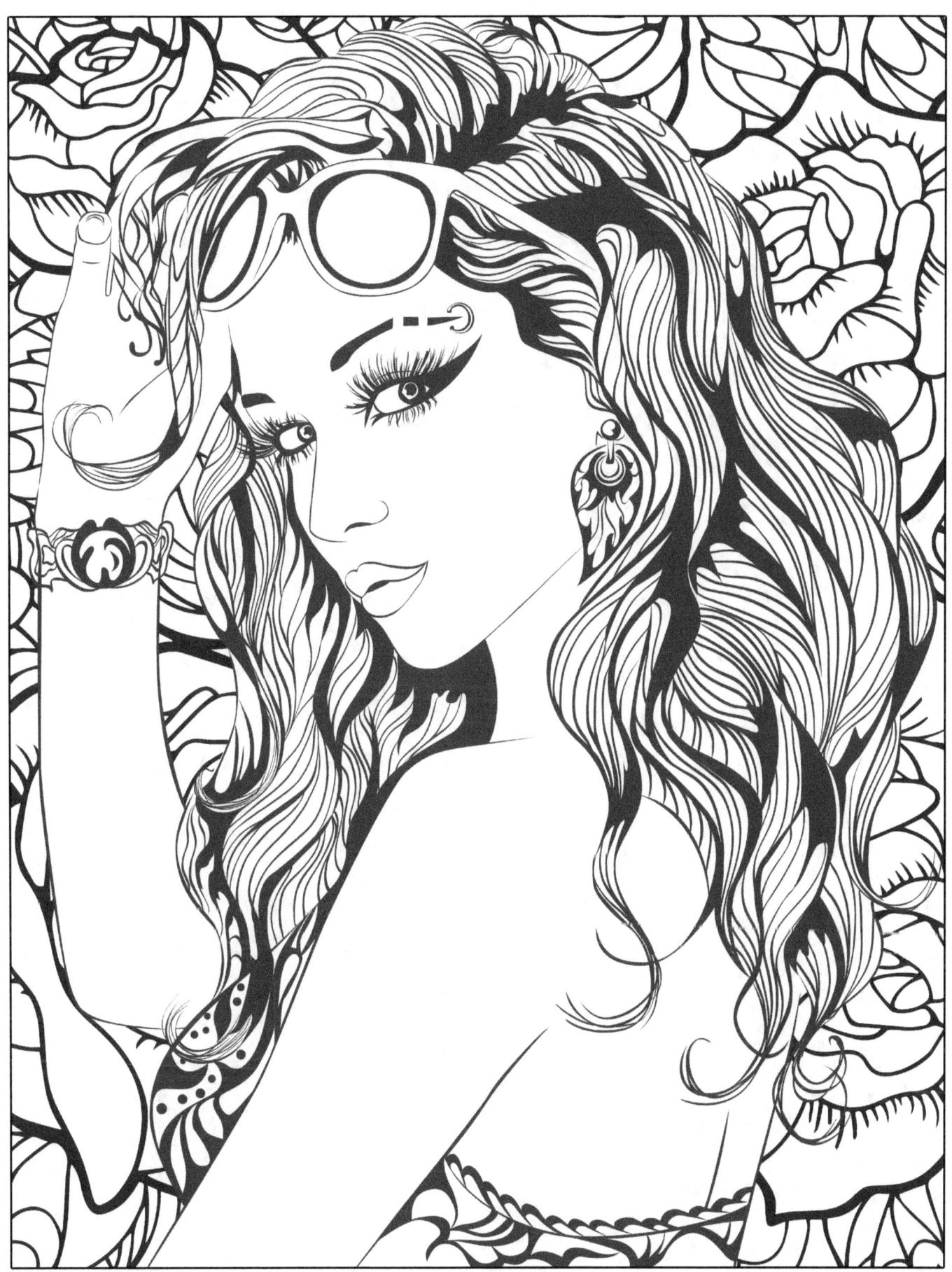

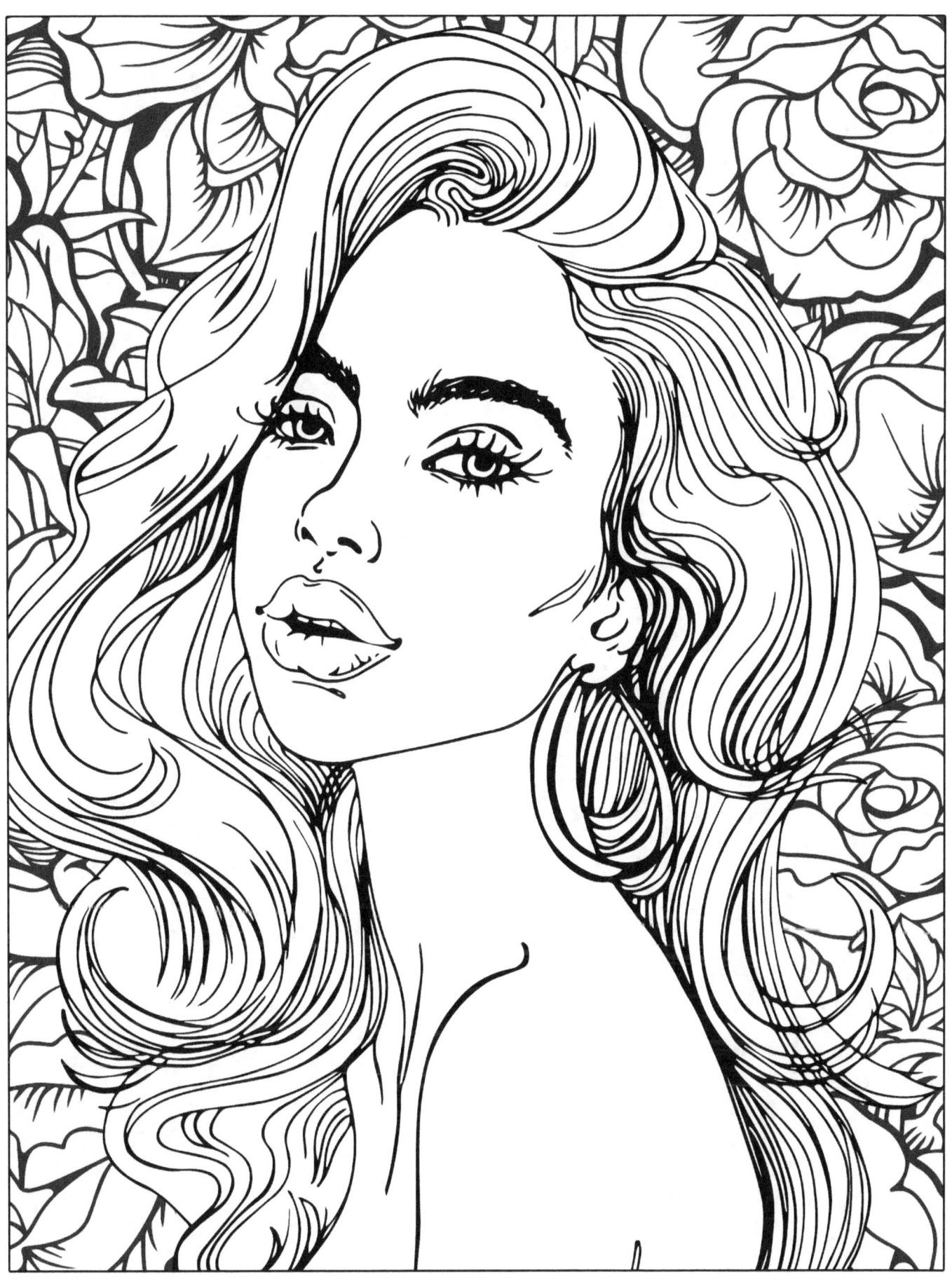

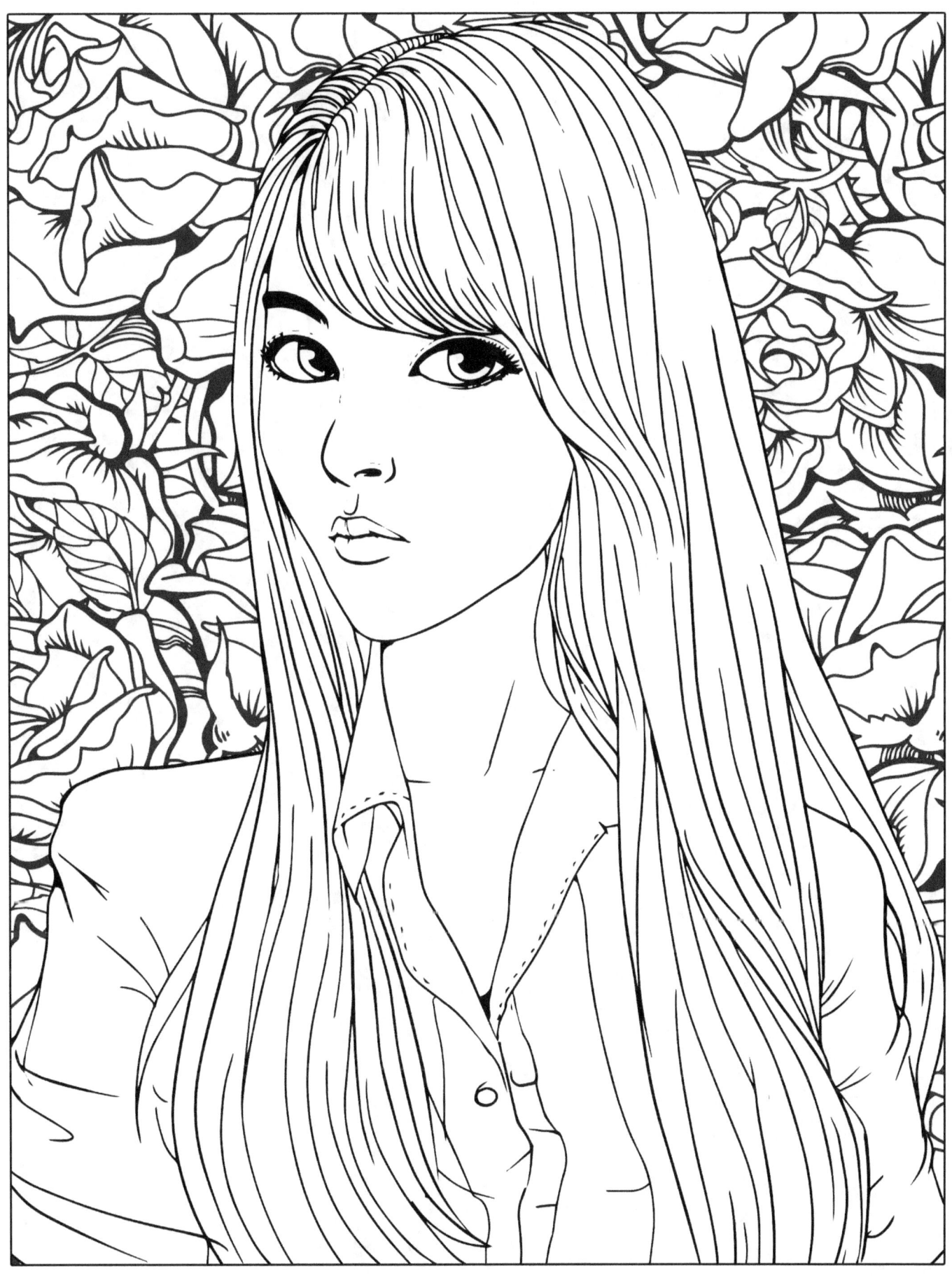

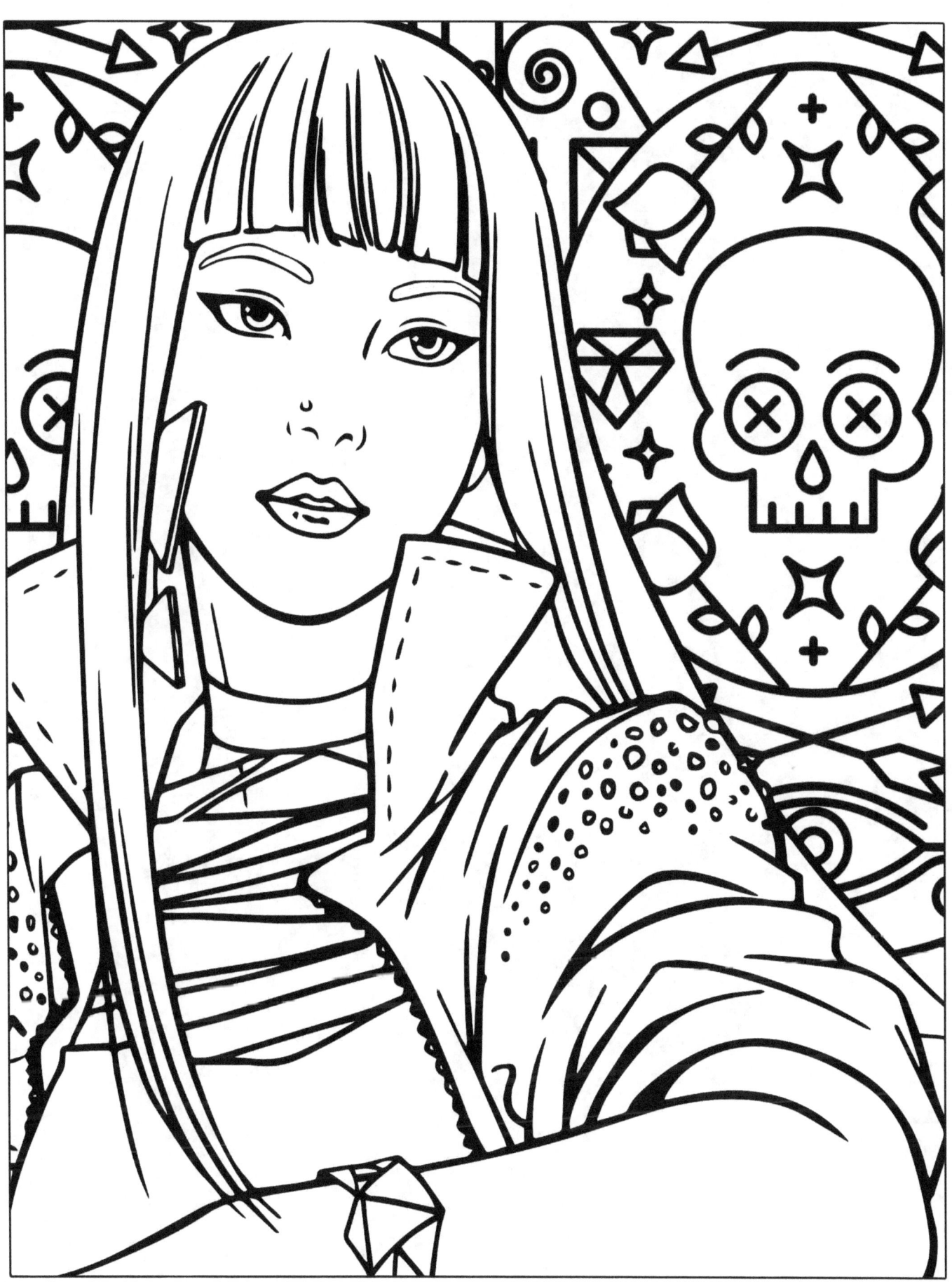

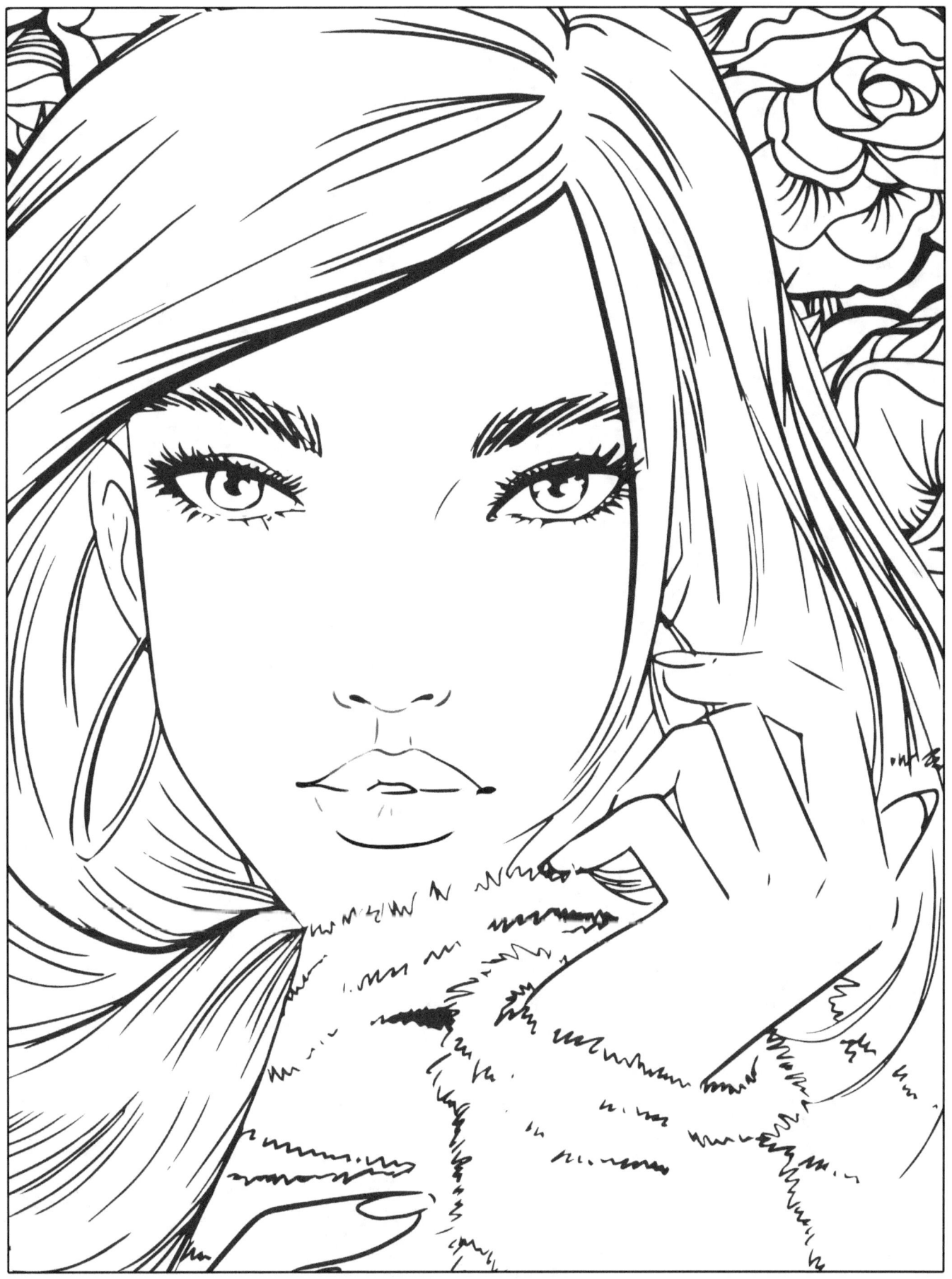

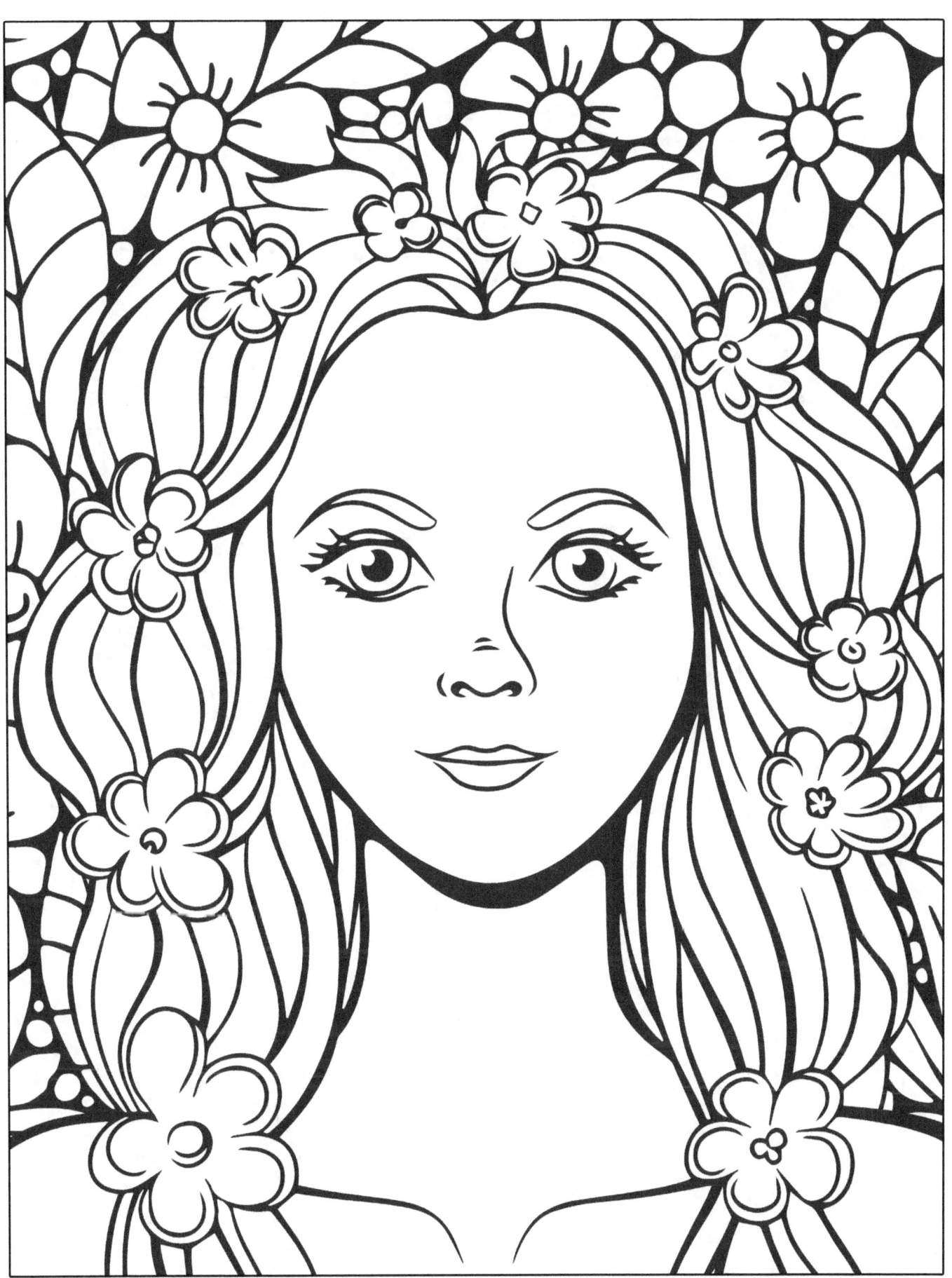

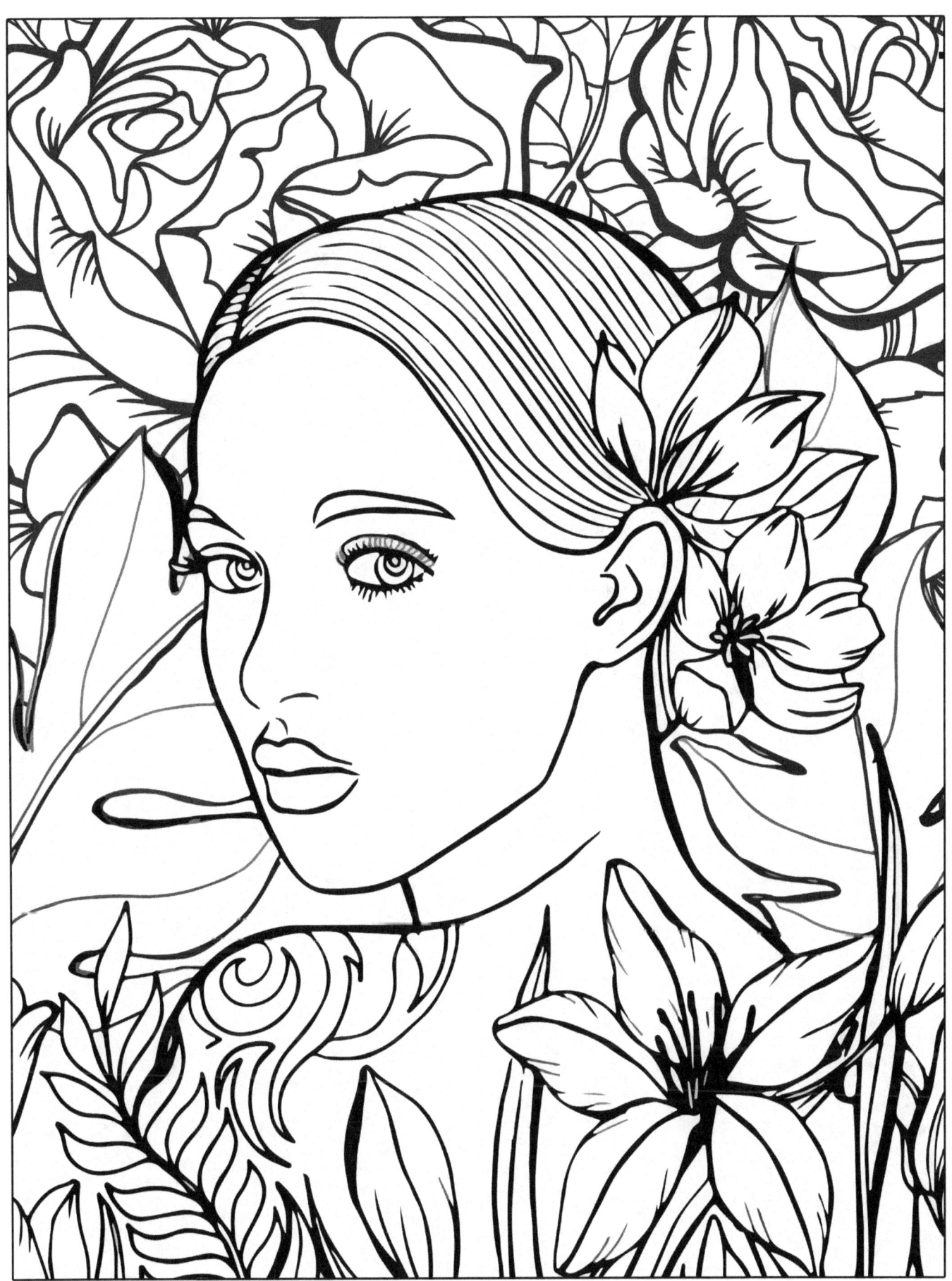

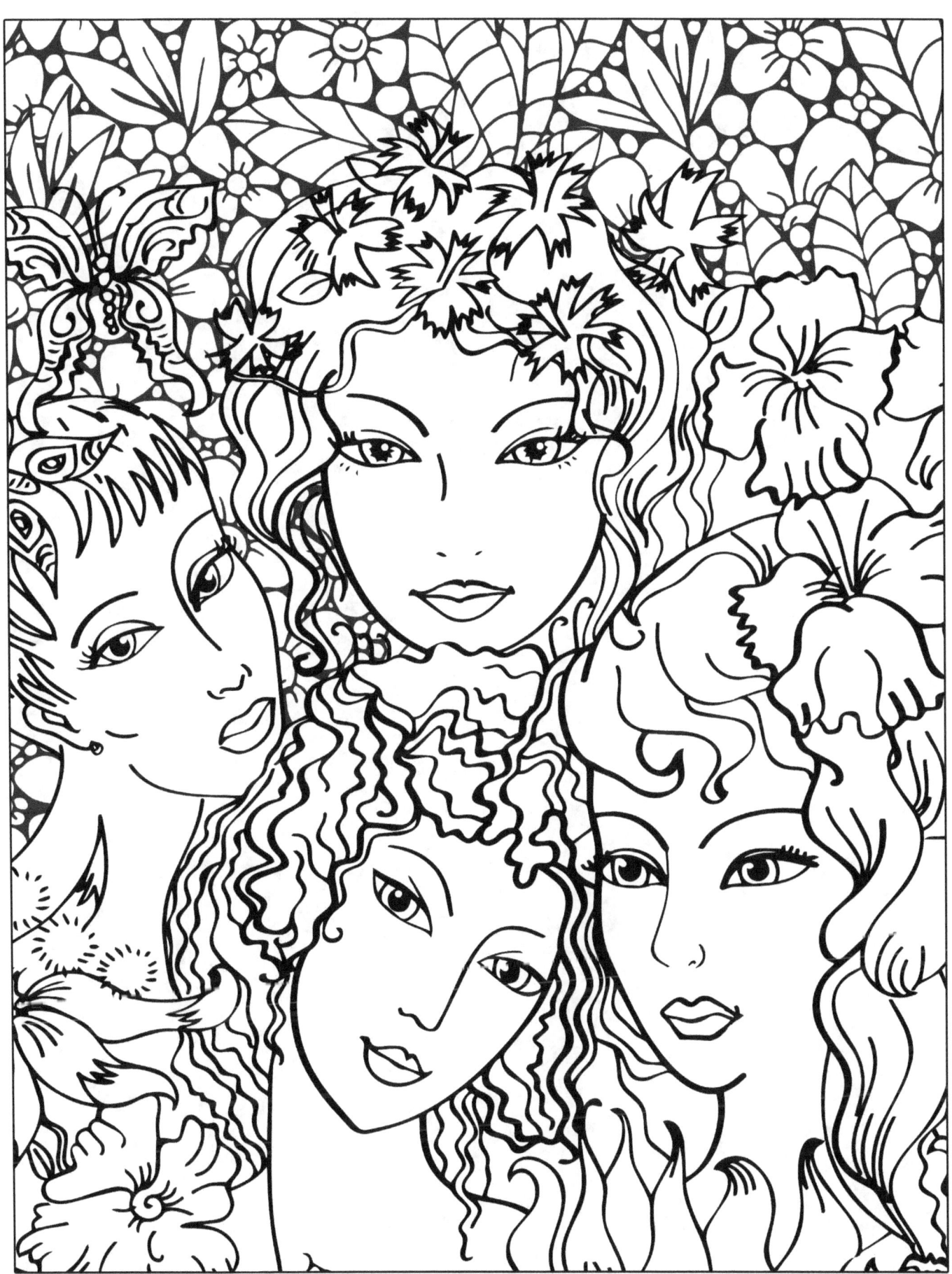

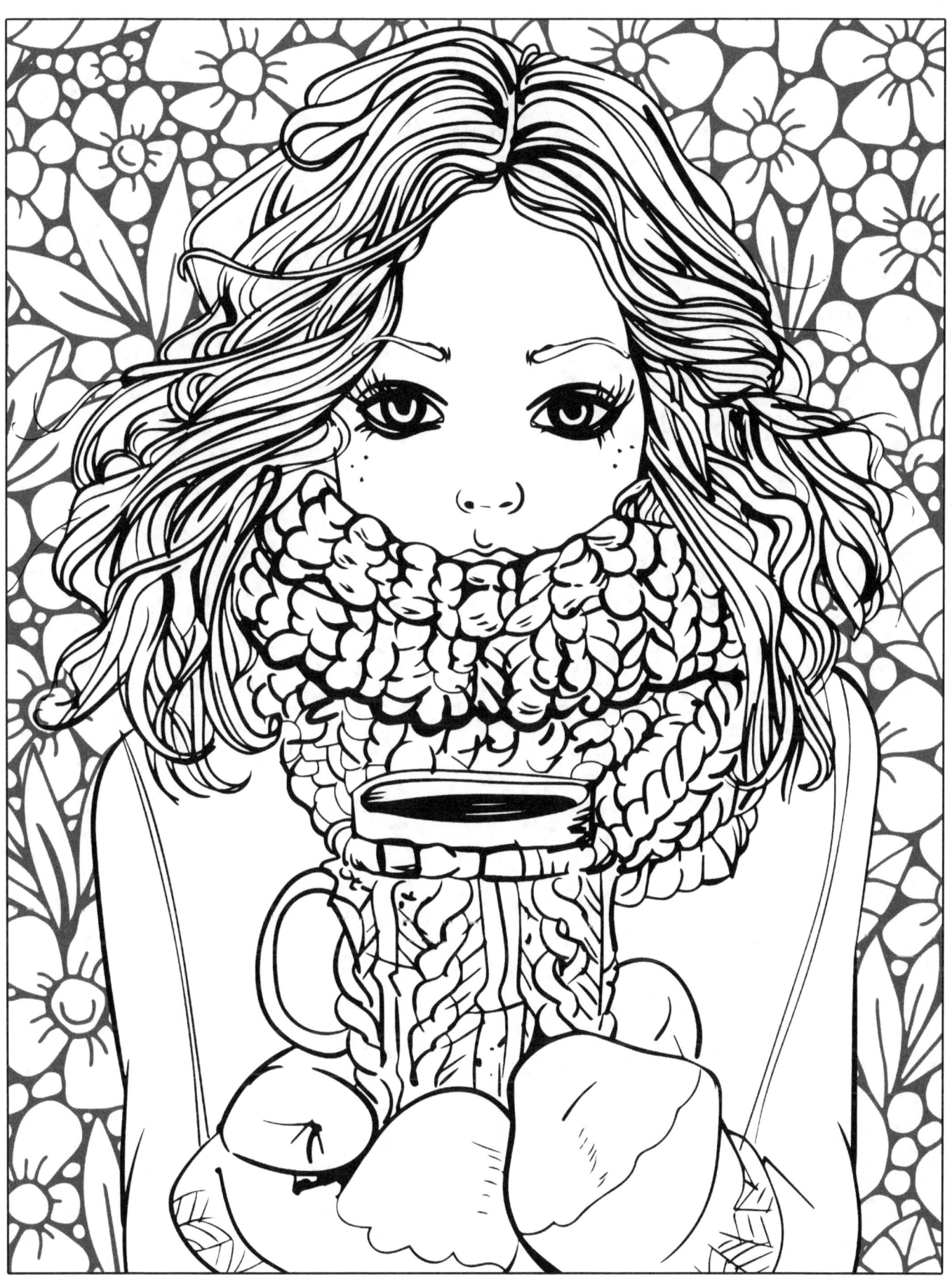

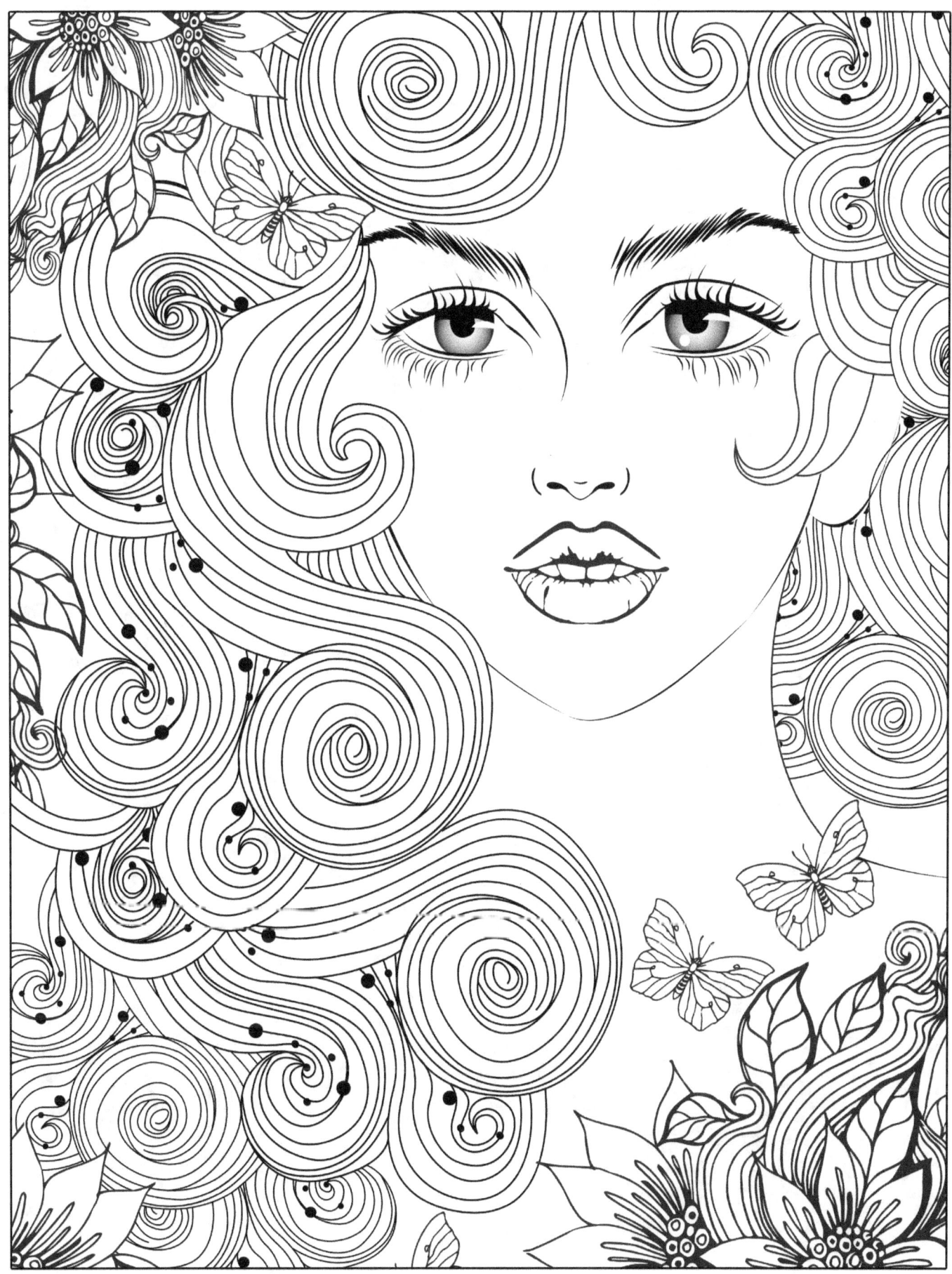

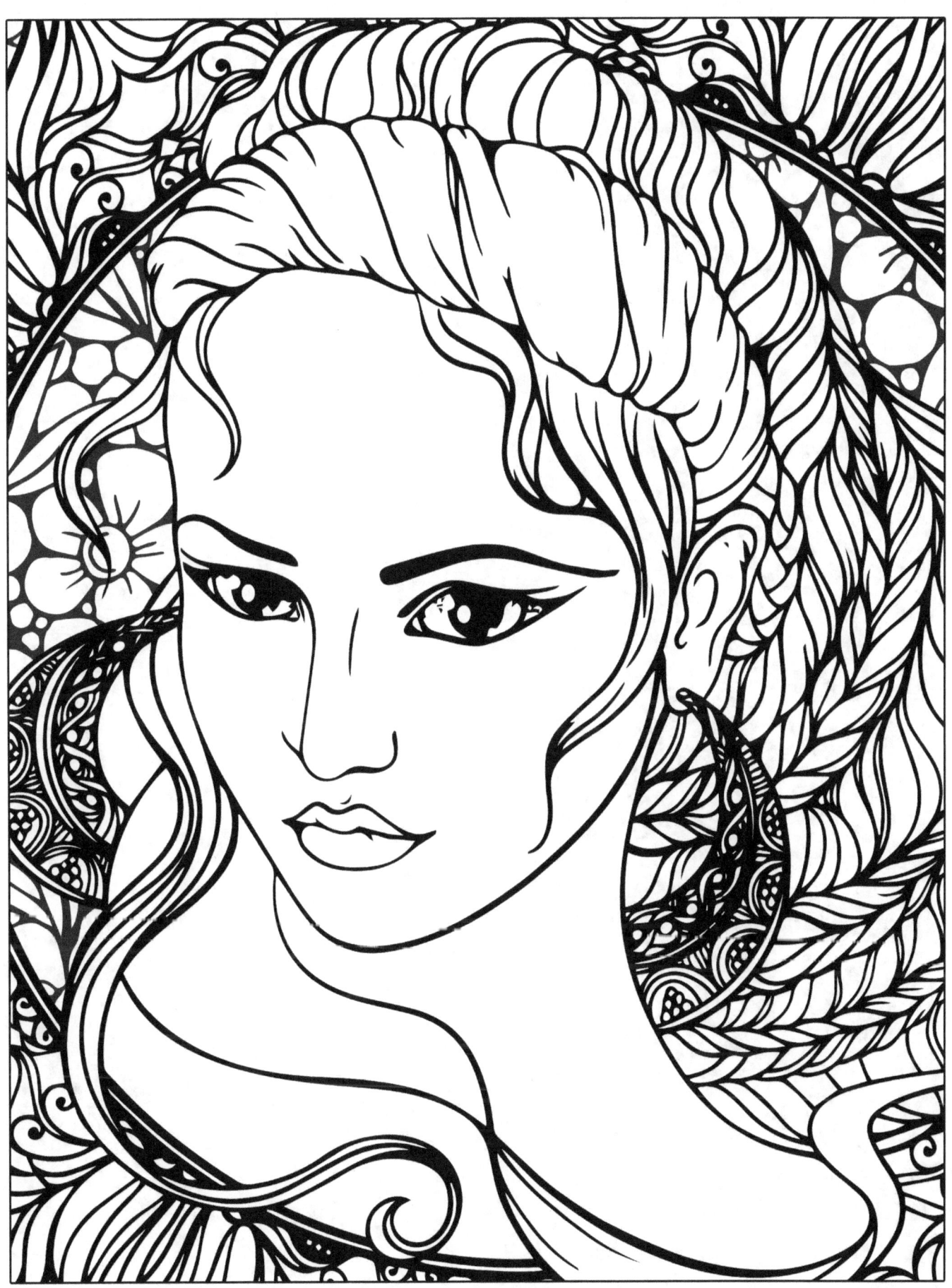

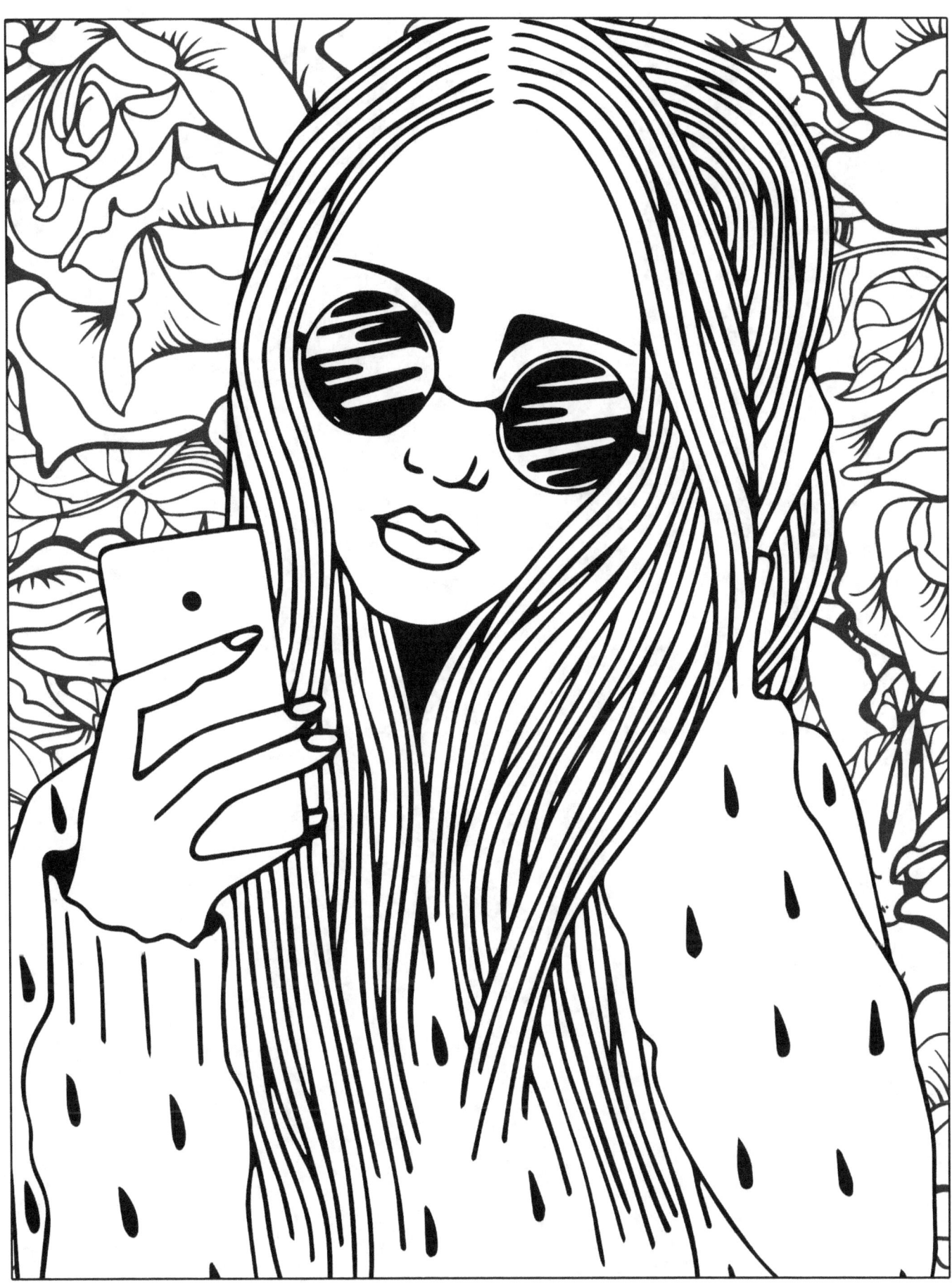

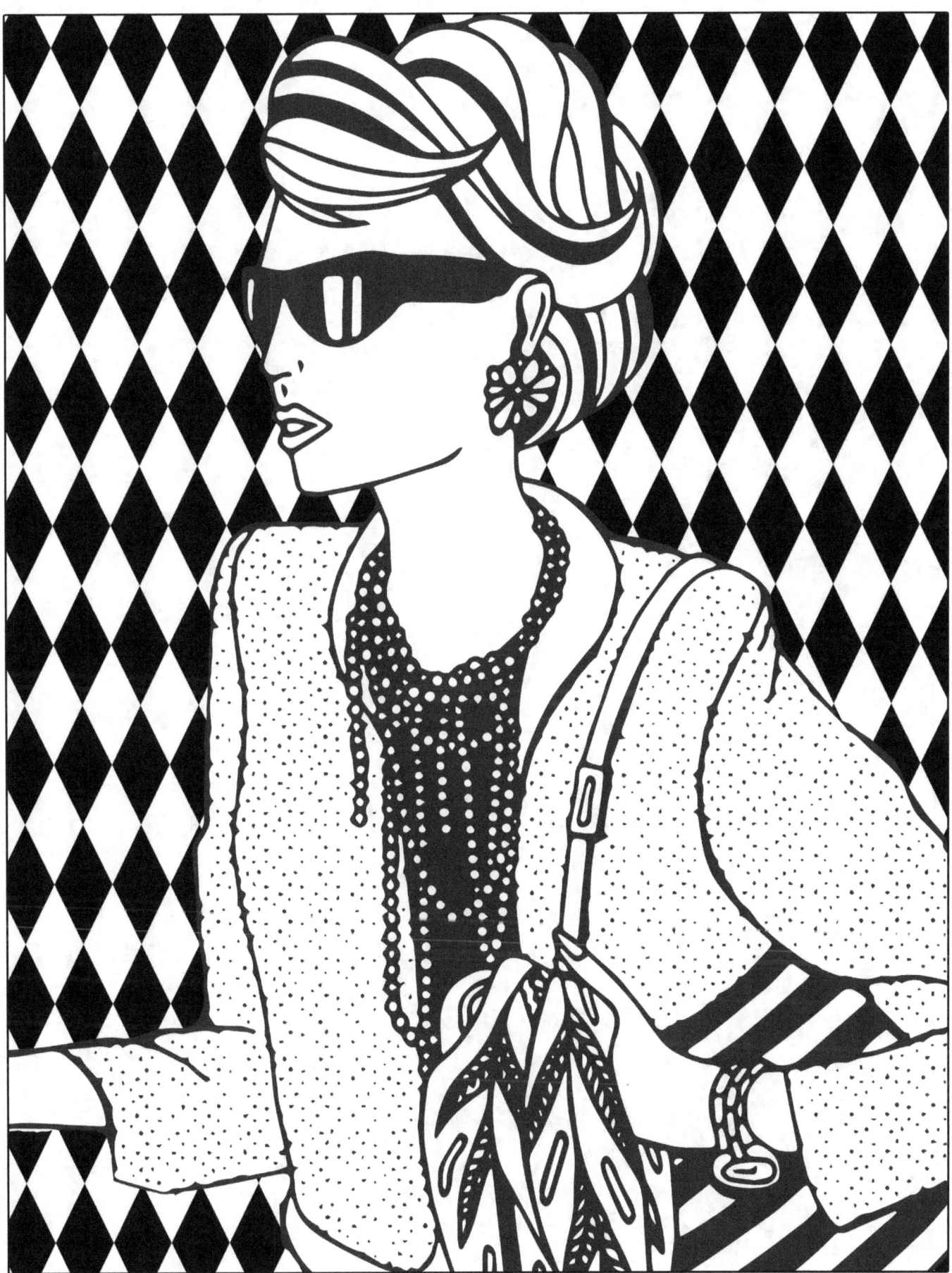

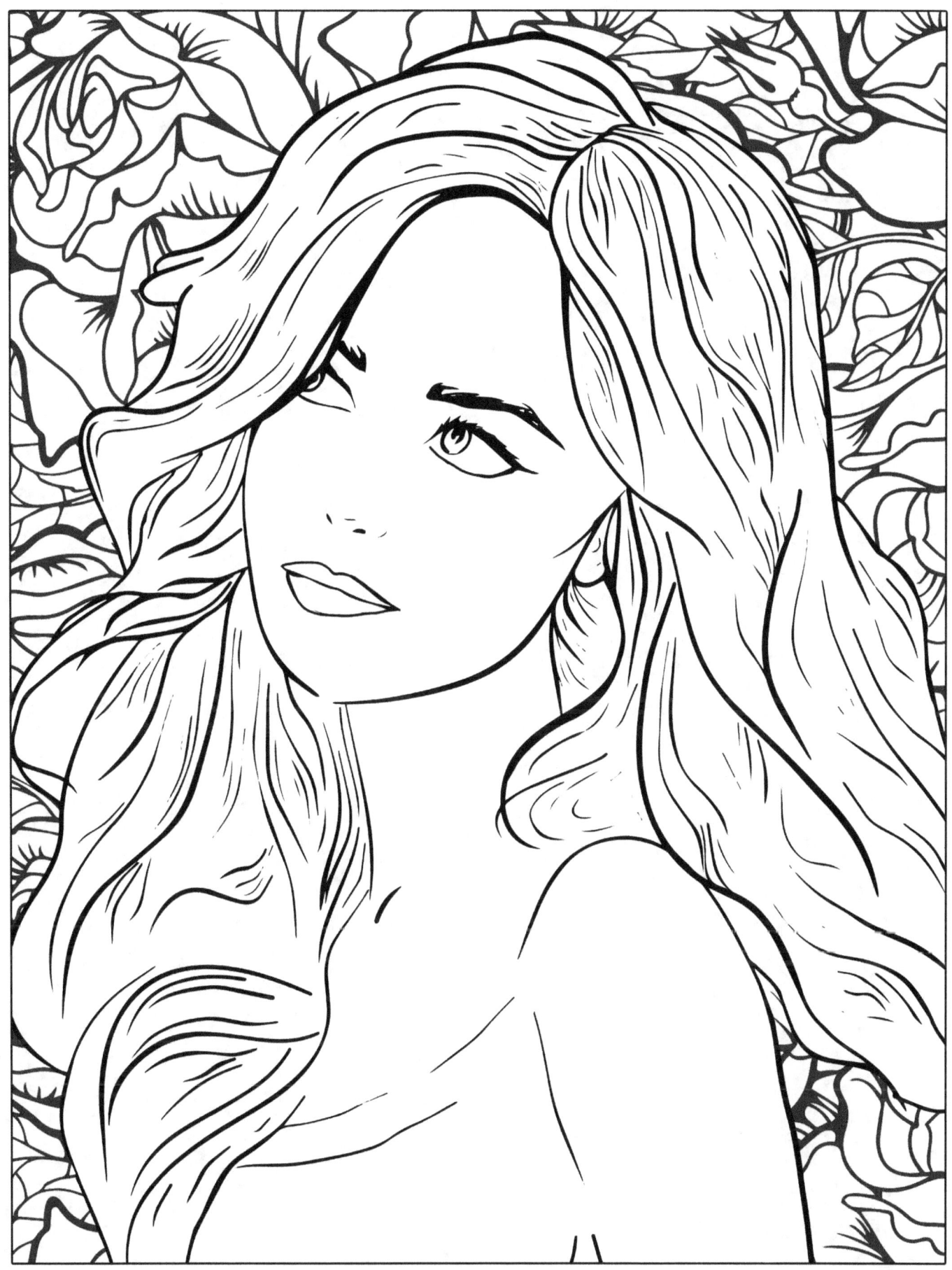

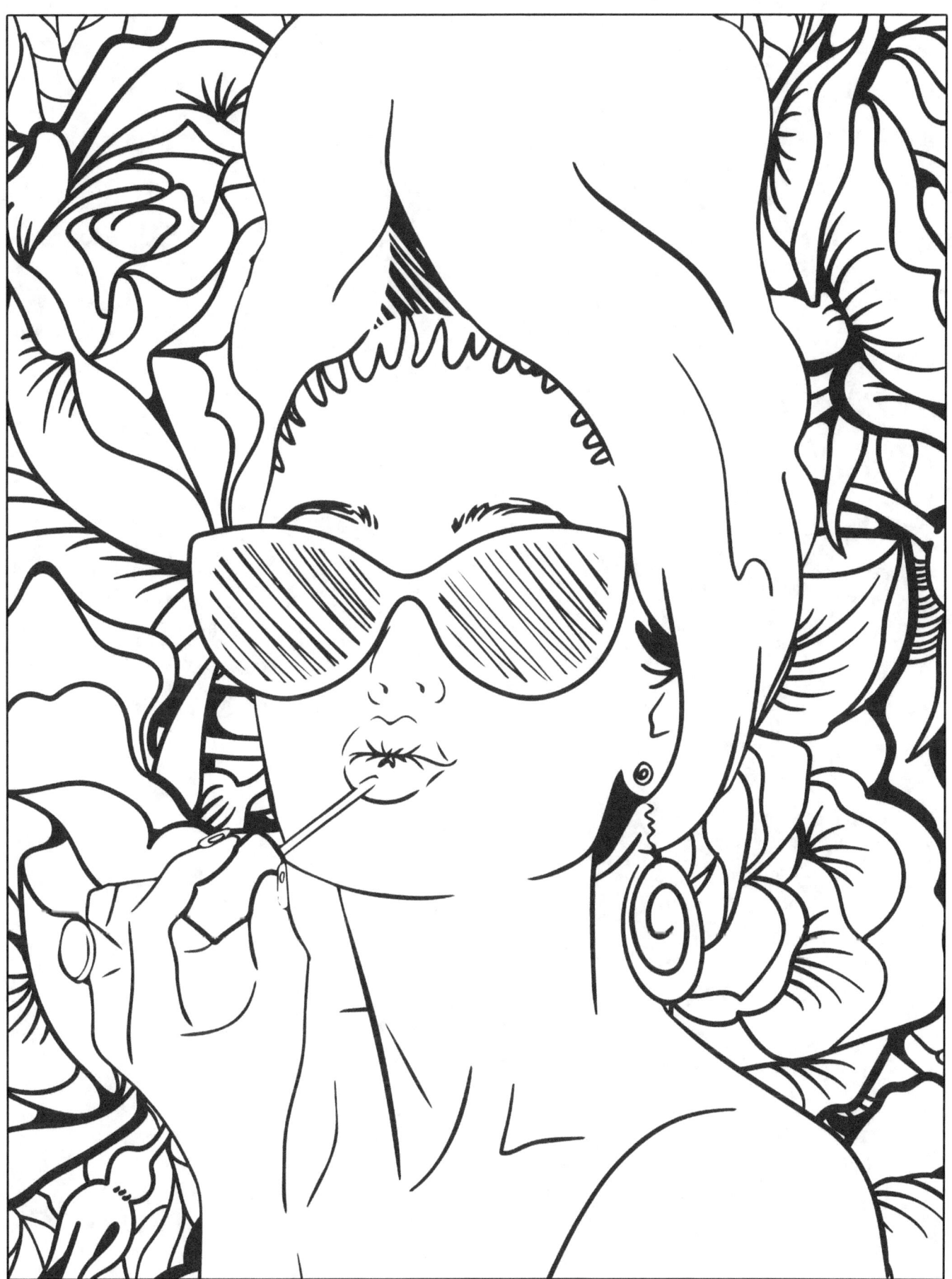

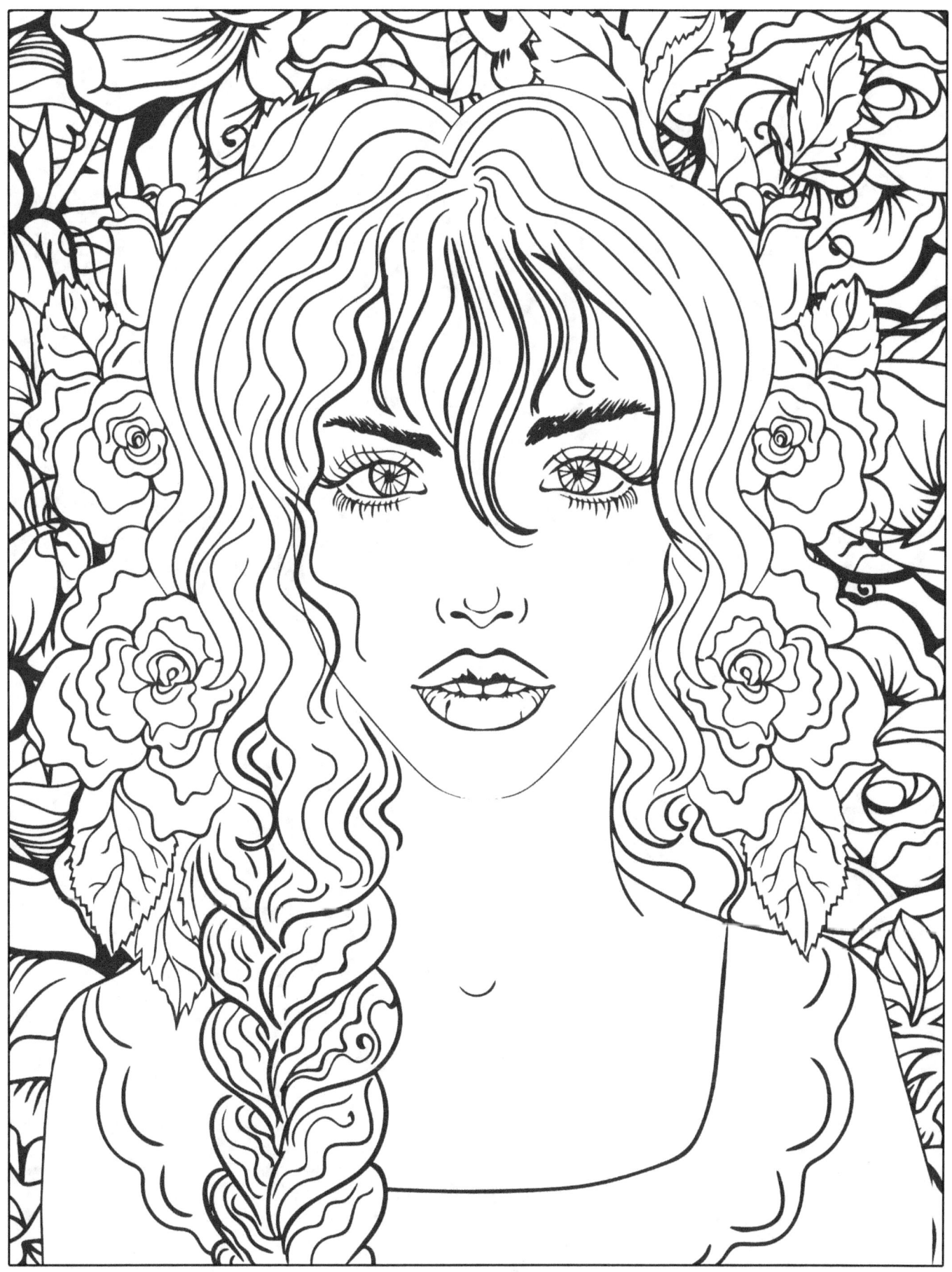

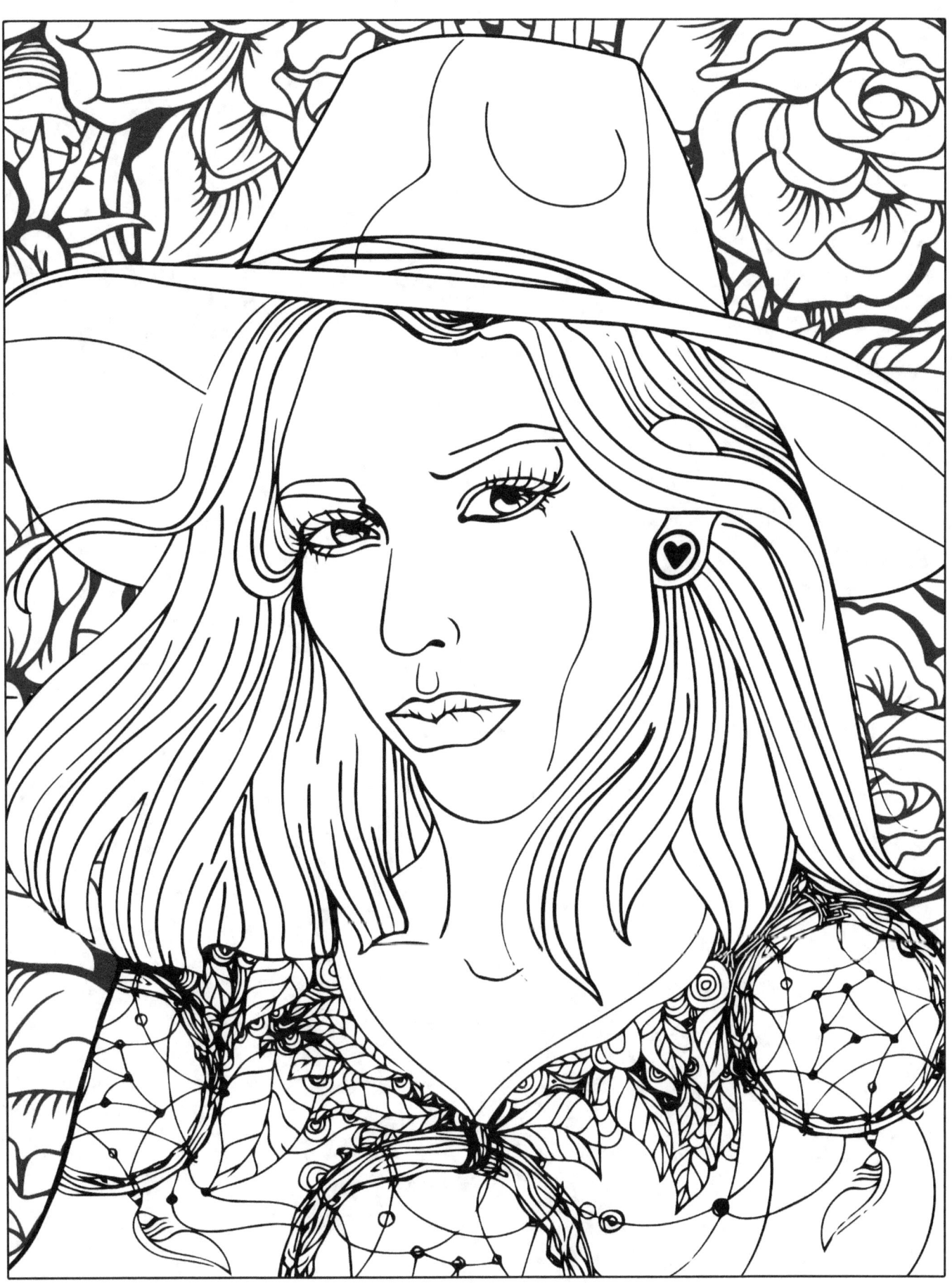

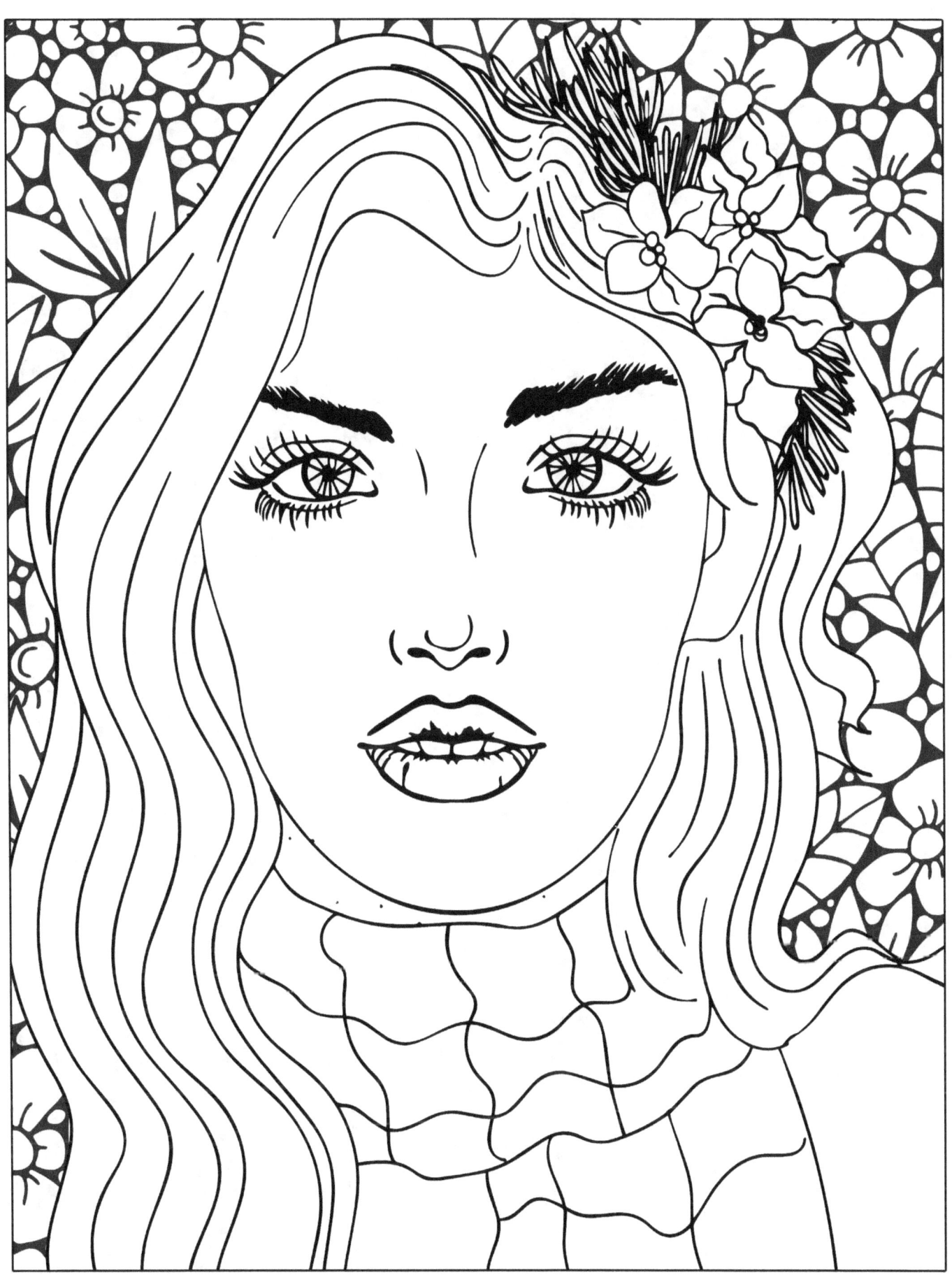

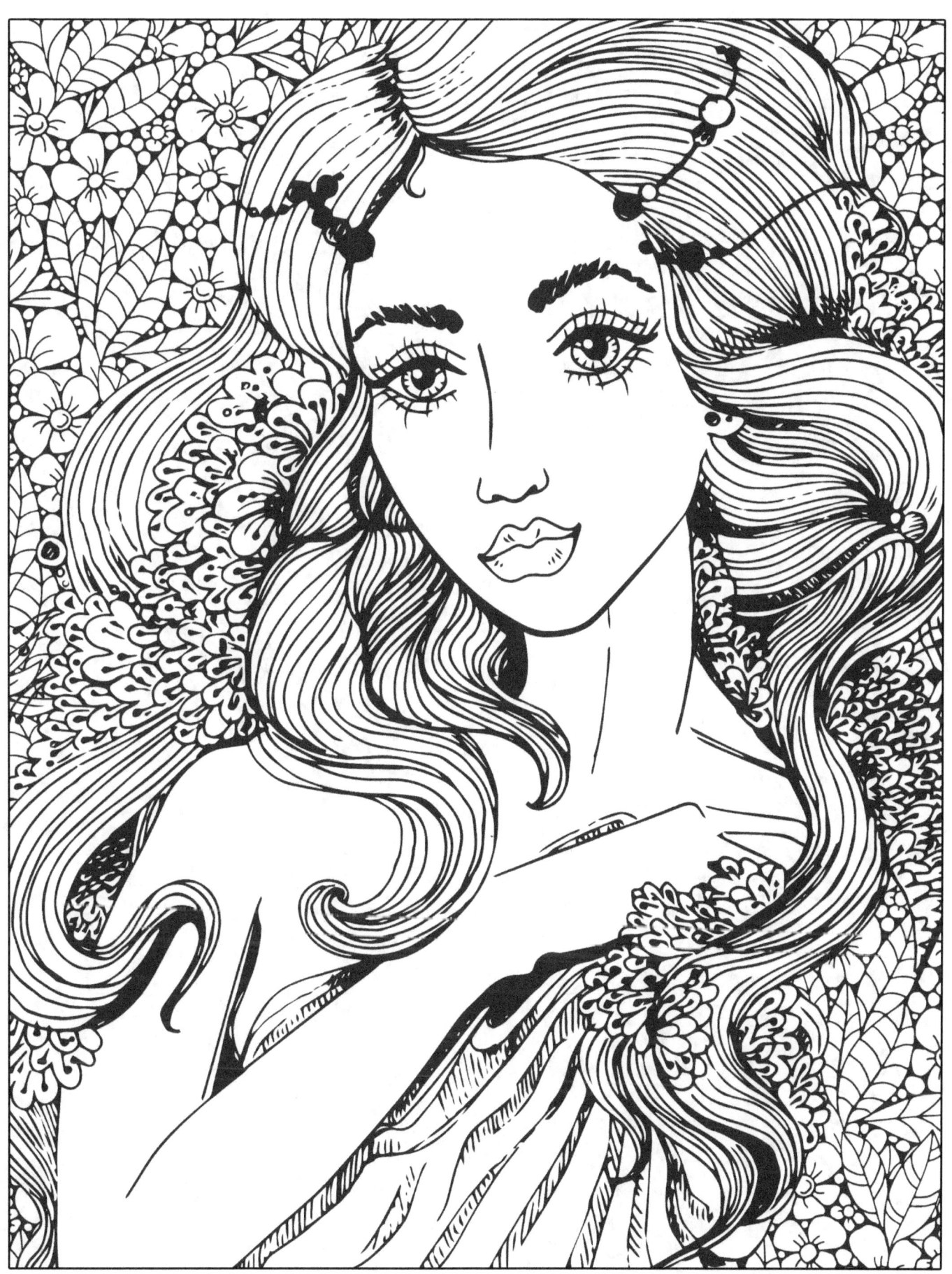

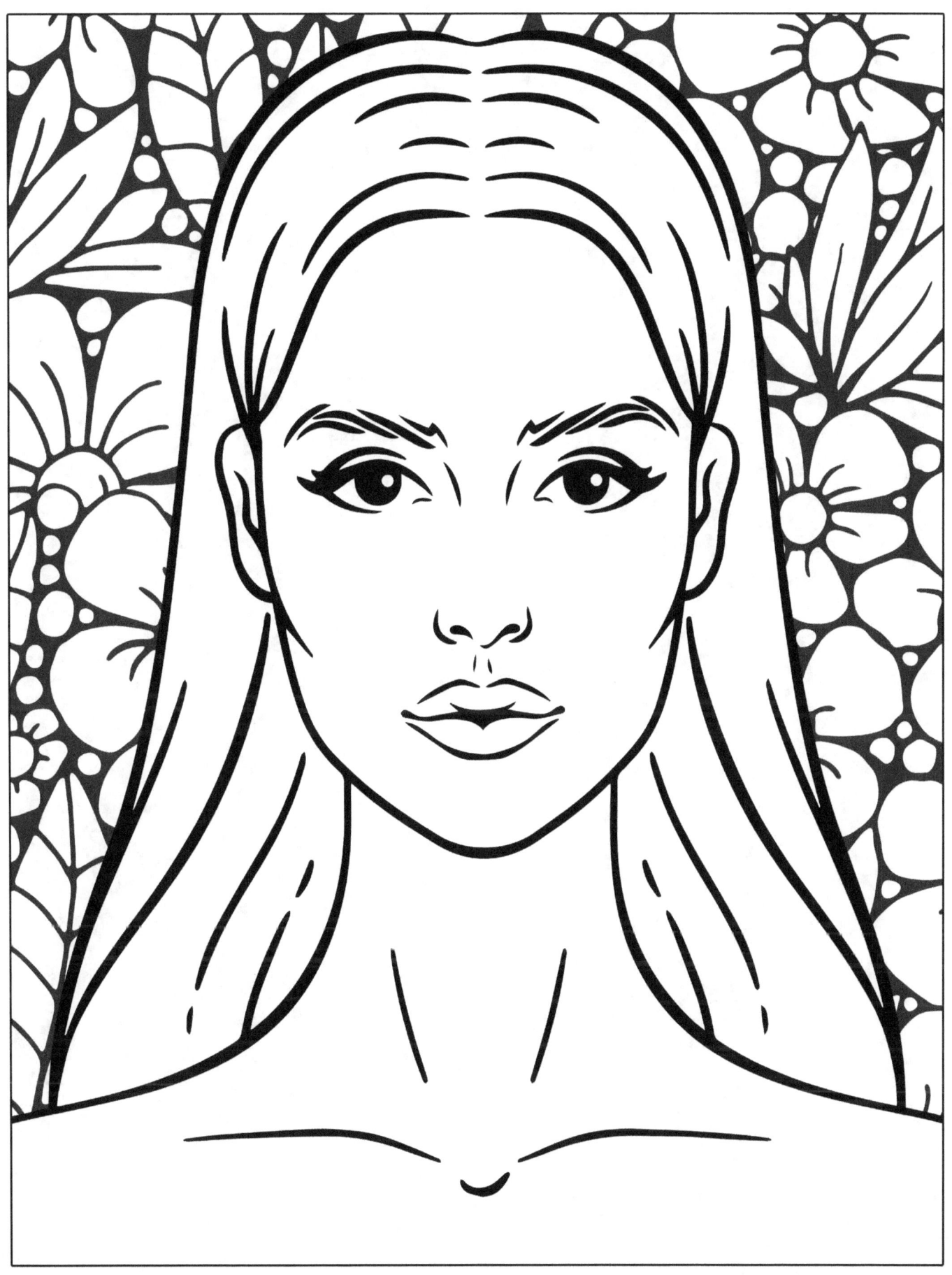

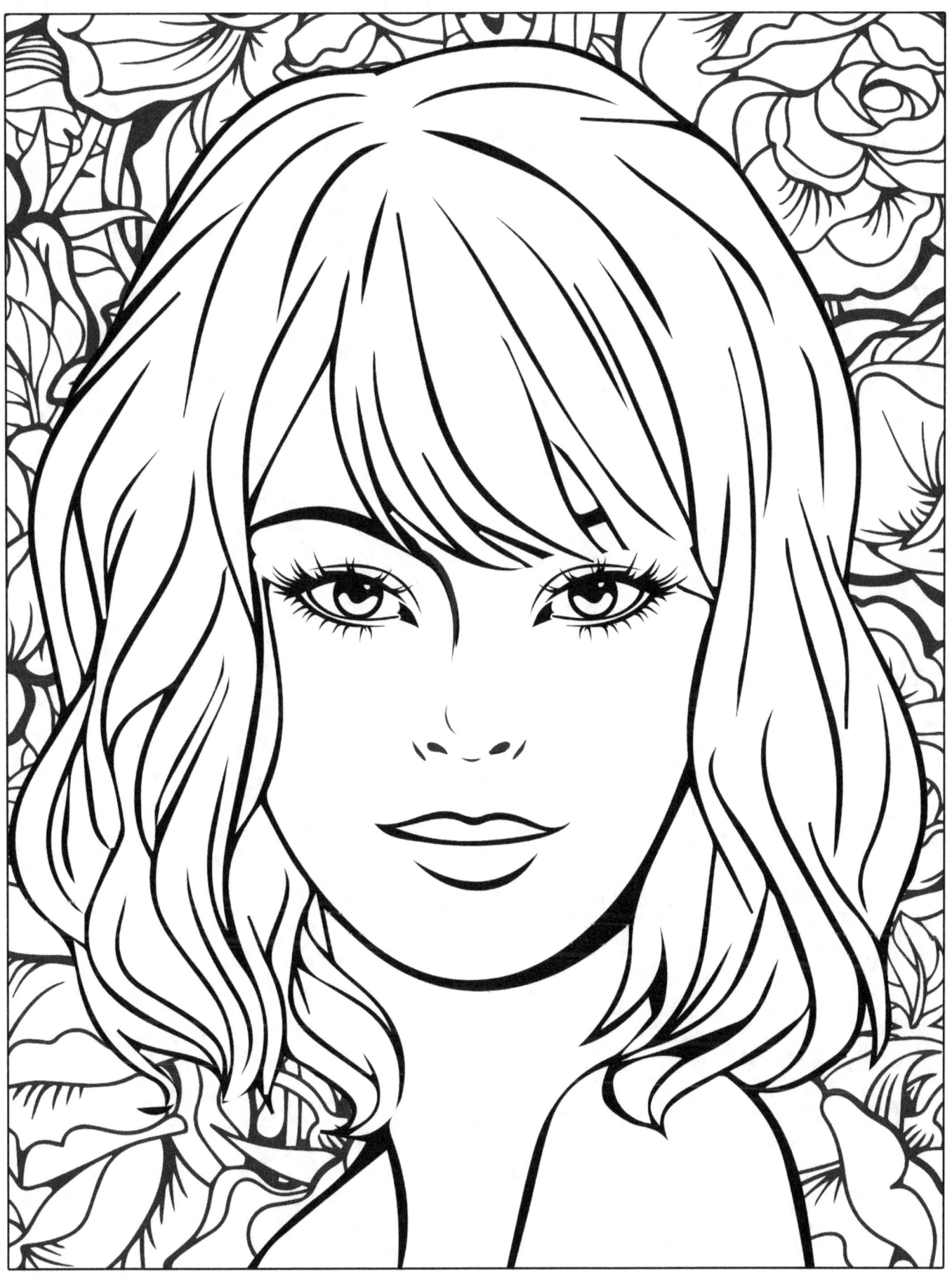

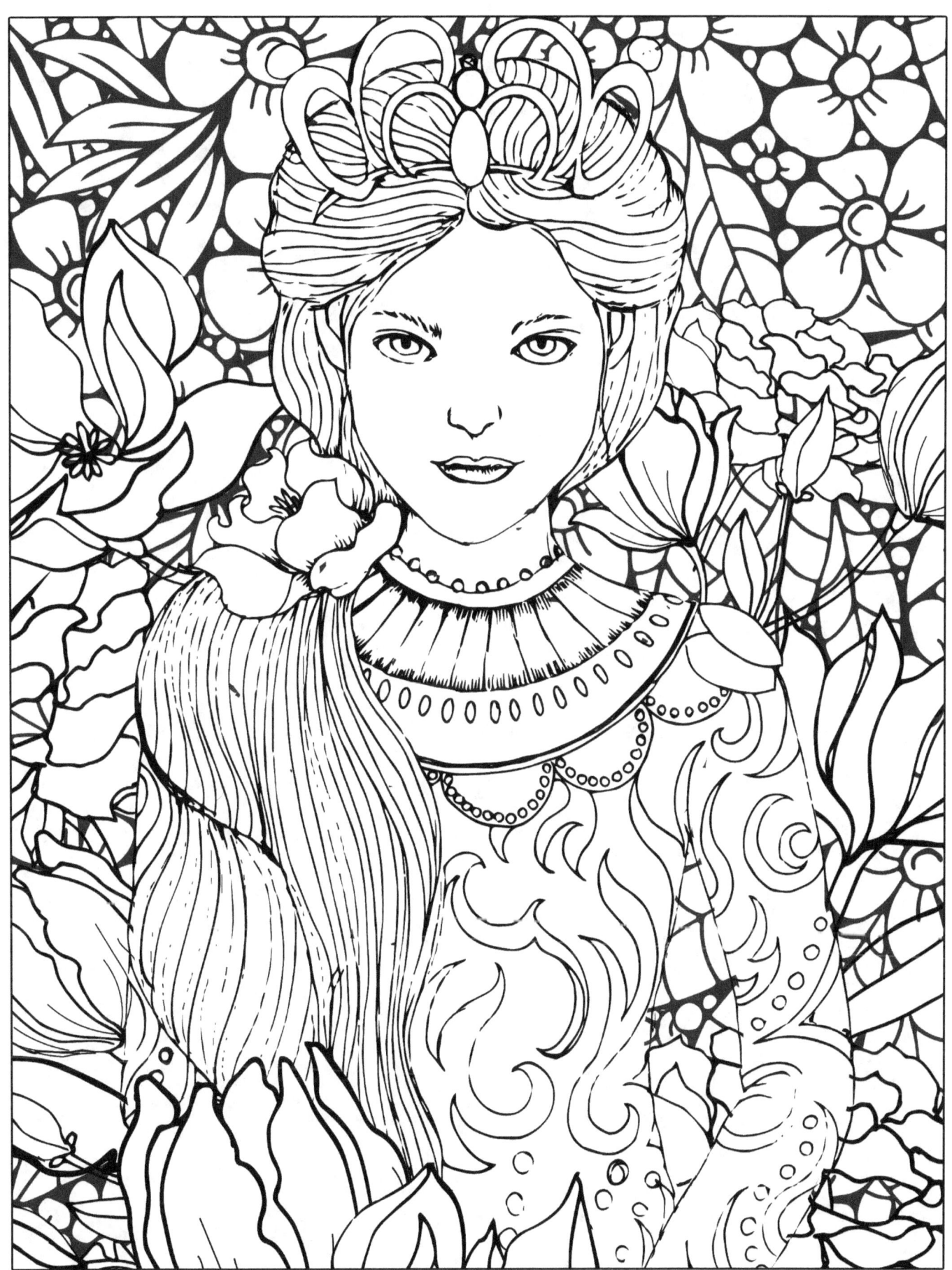

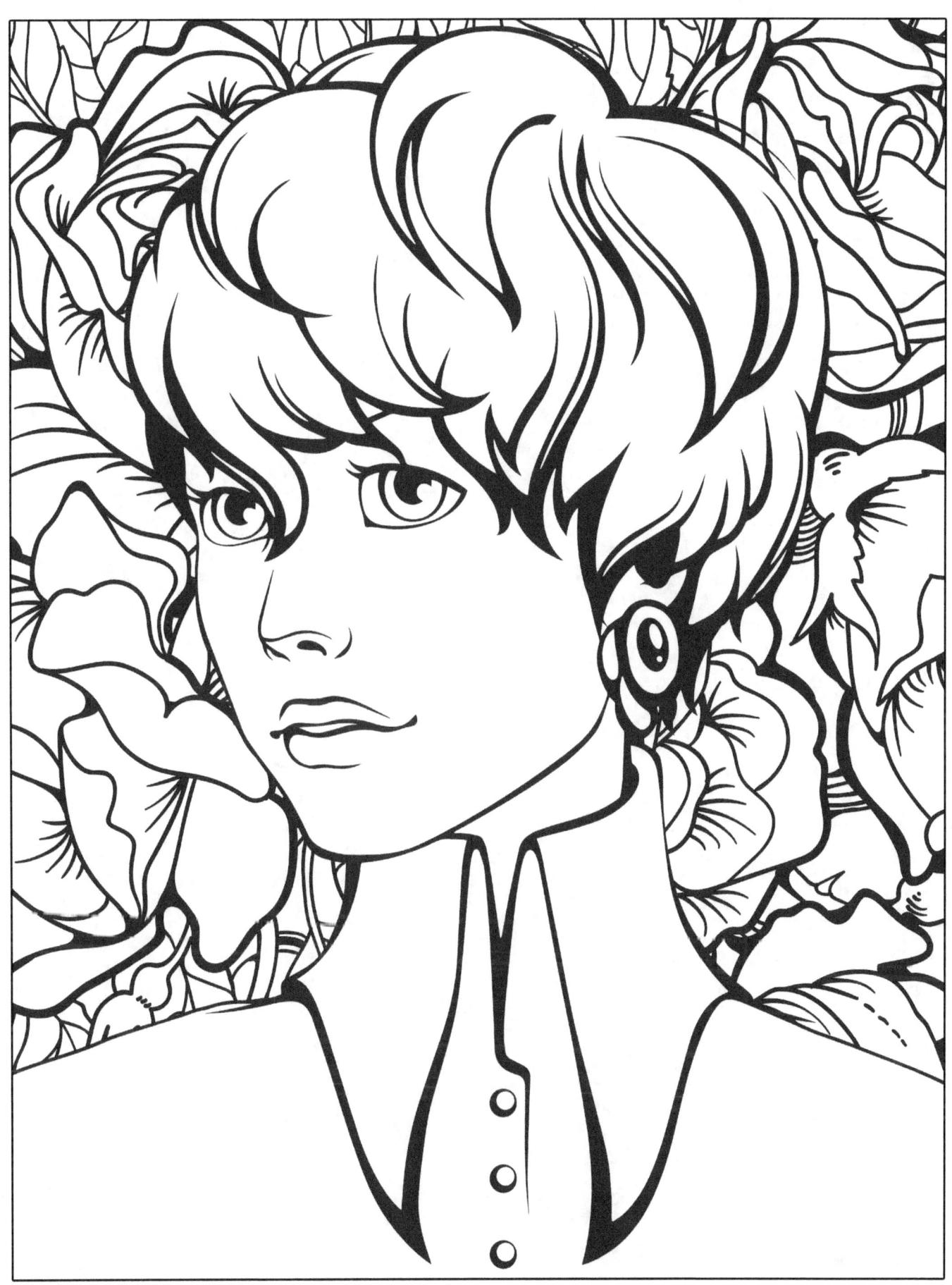

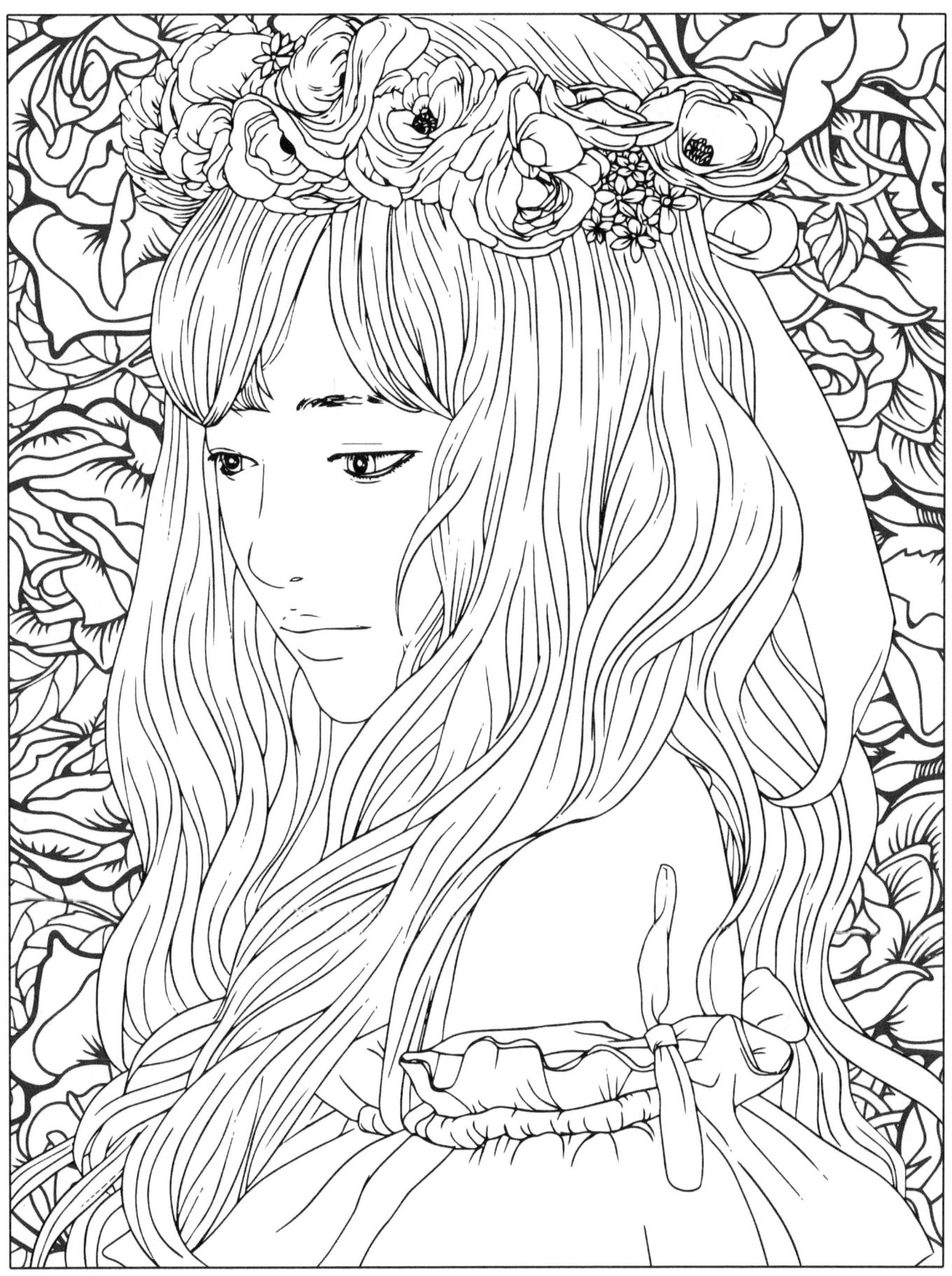

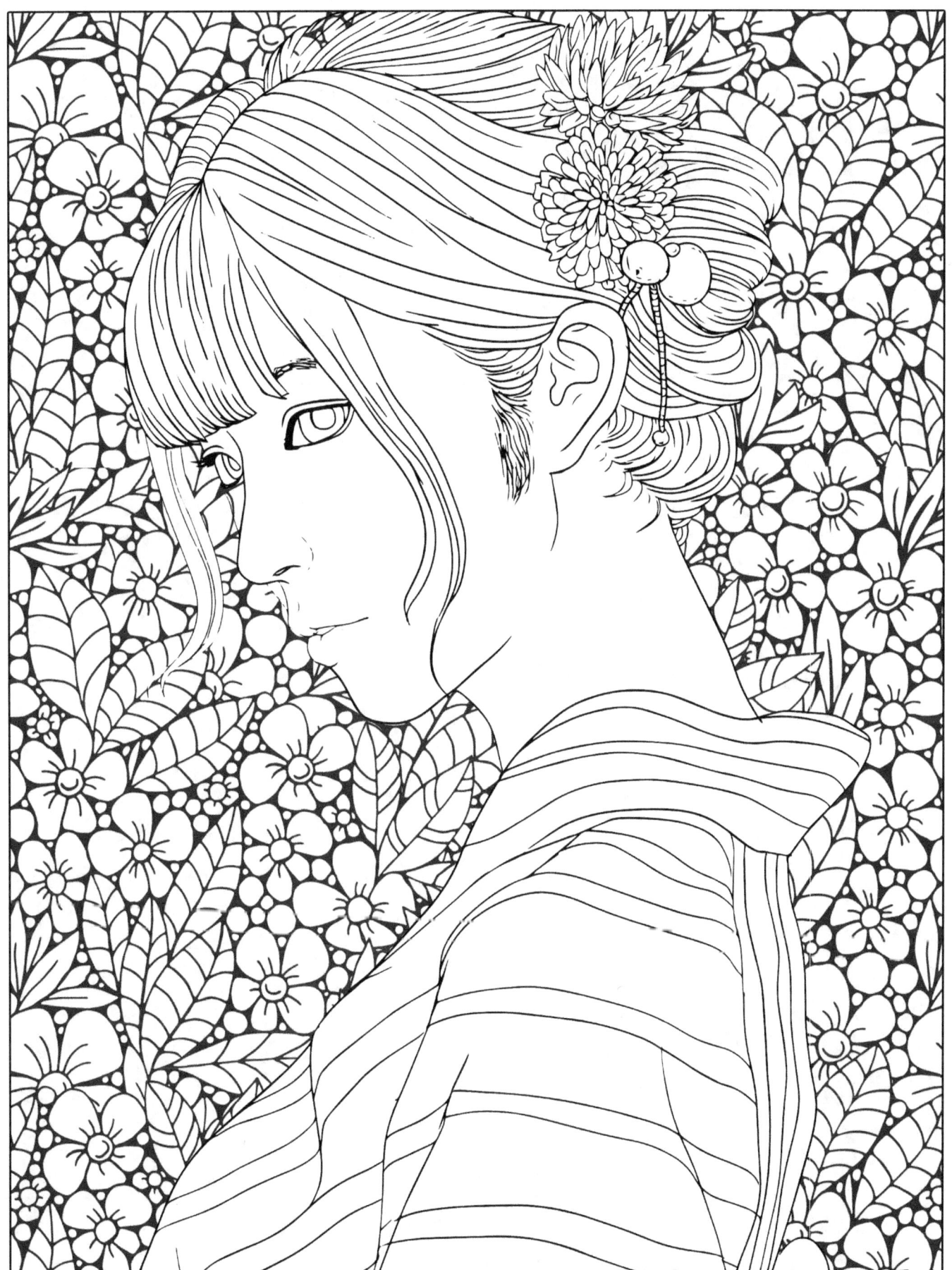

VERSION 2

KREATIF LOUNGE

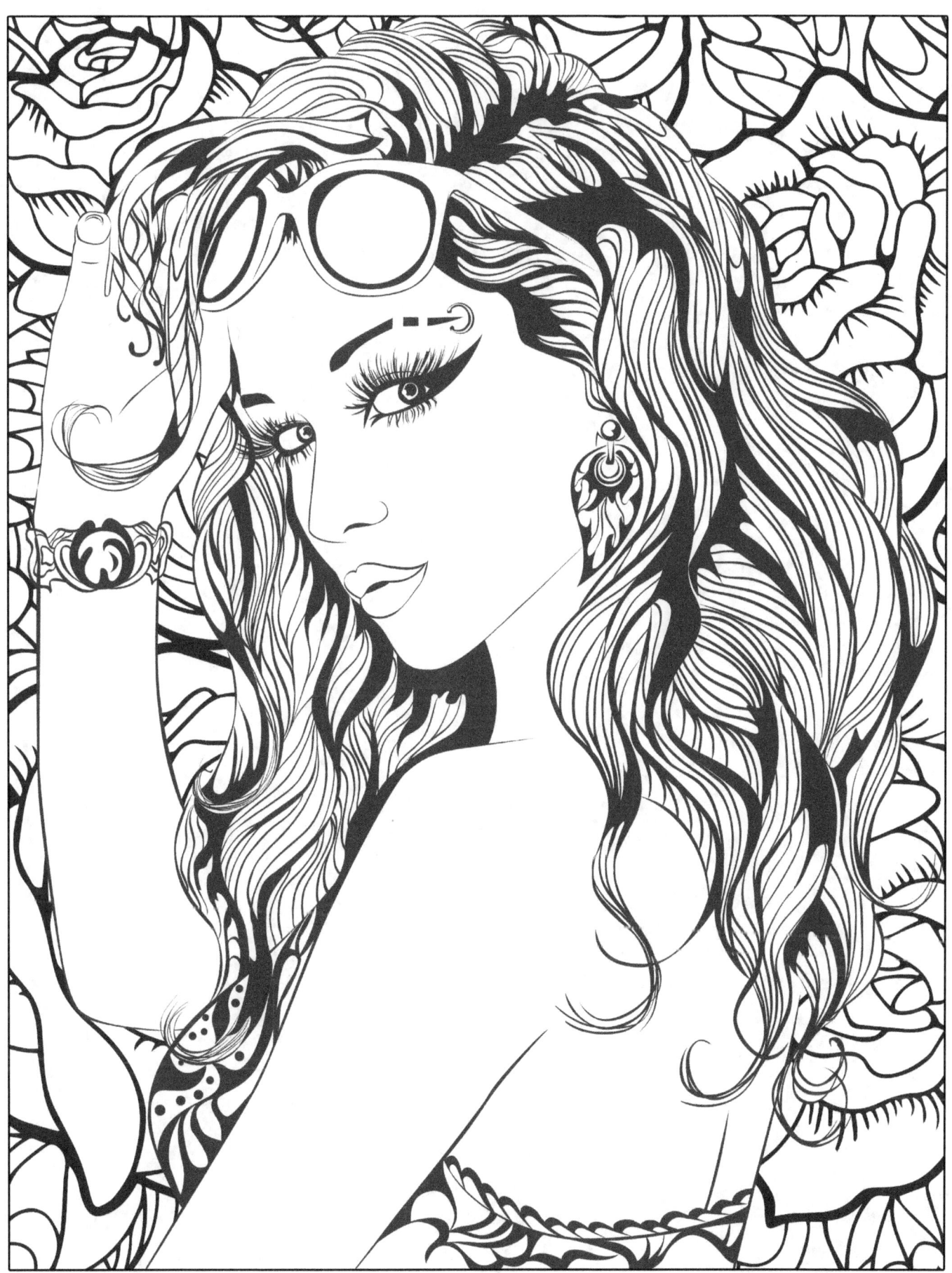

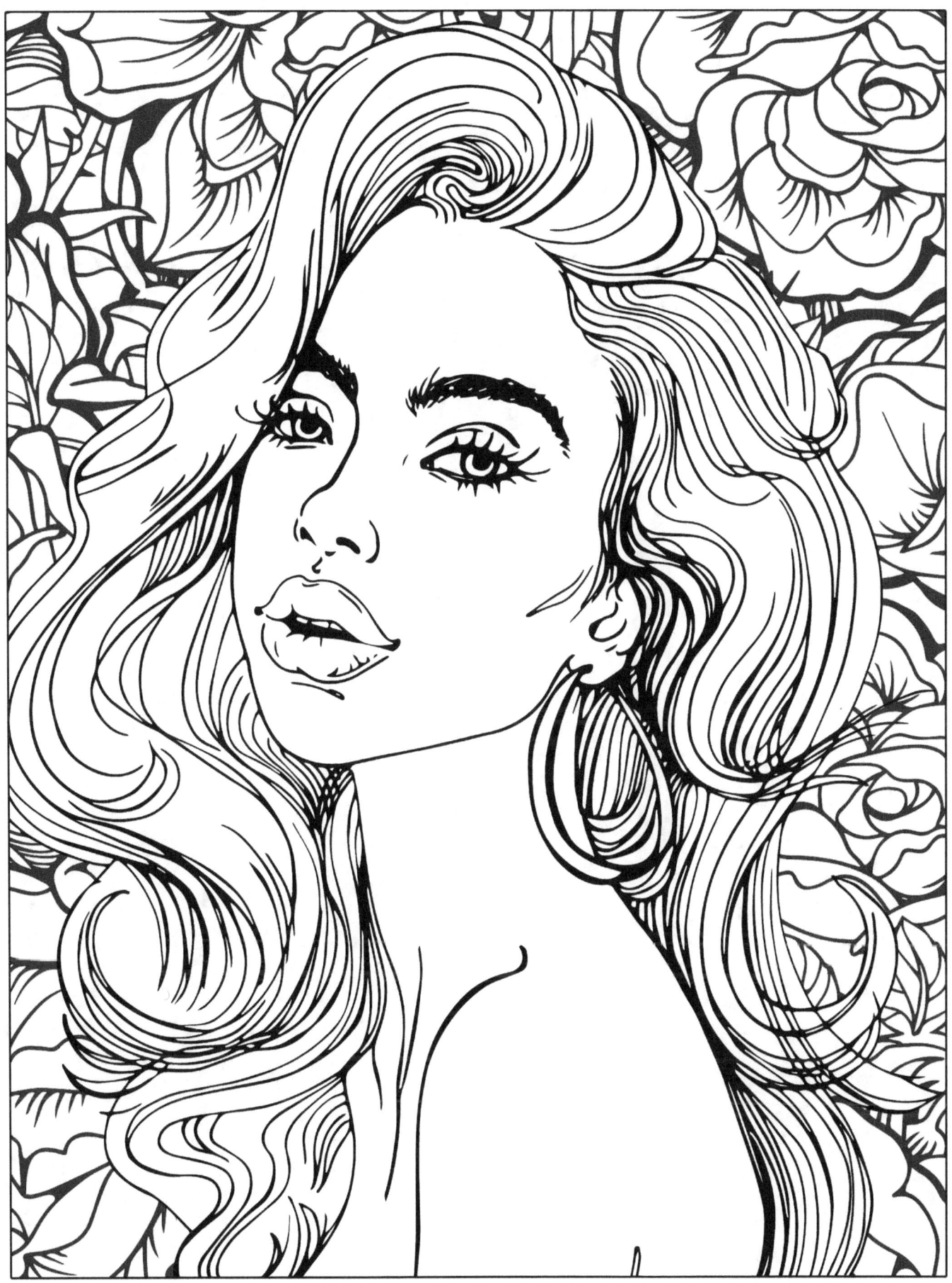

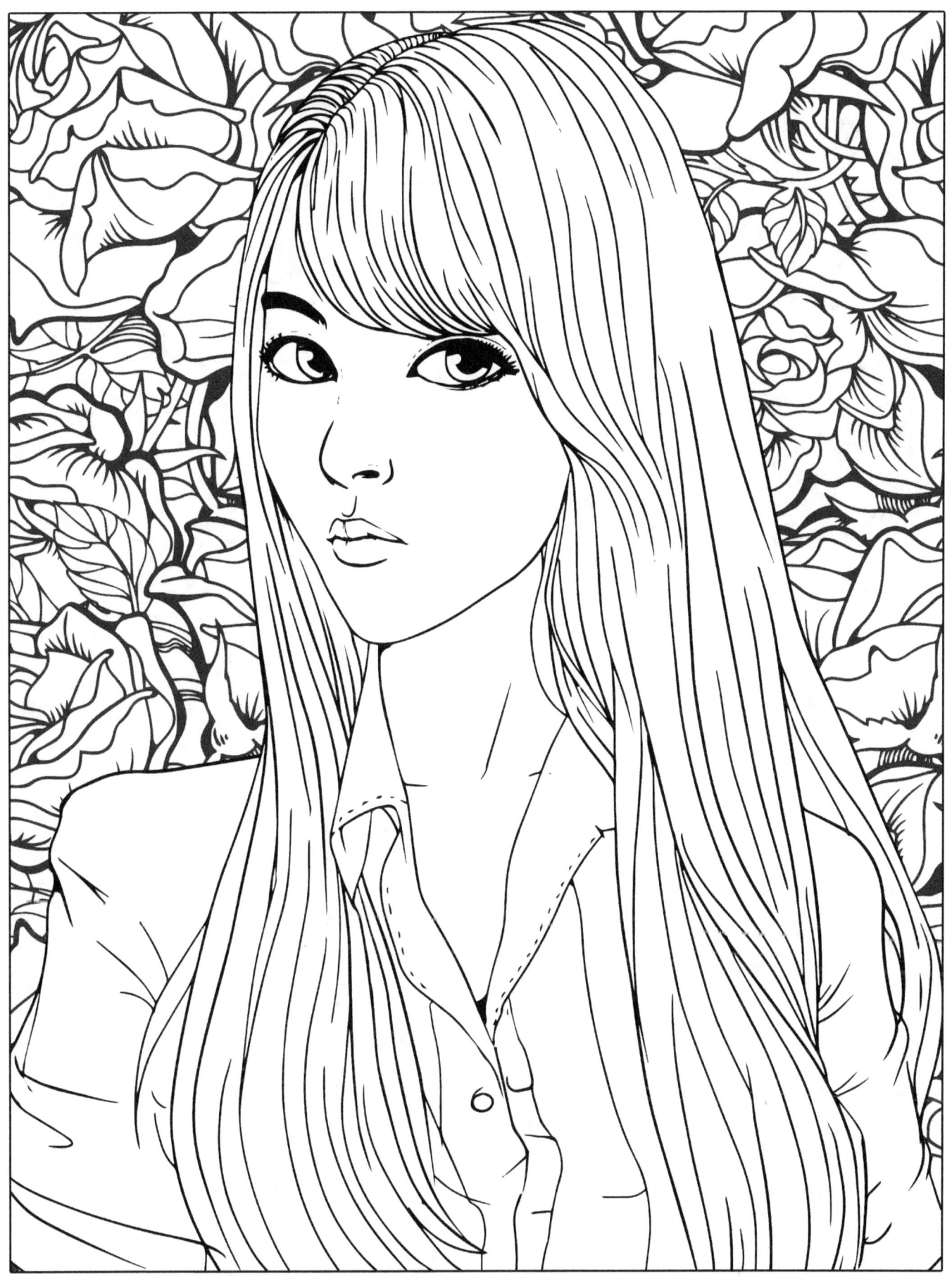

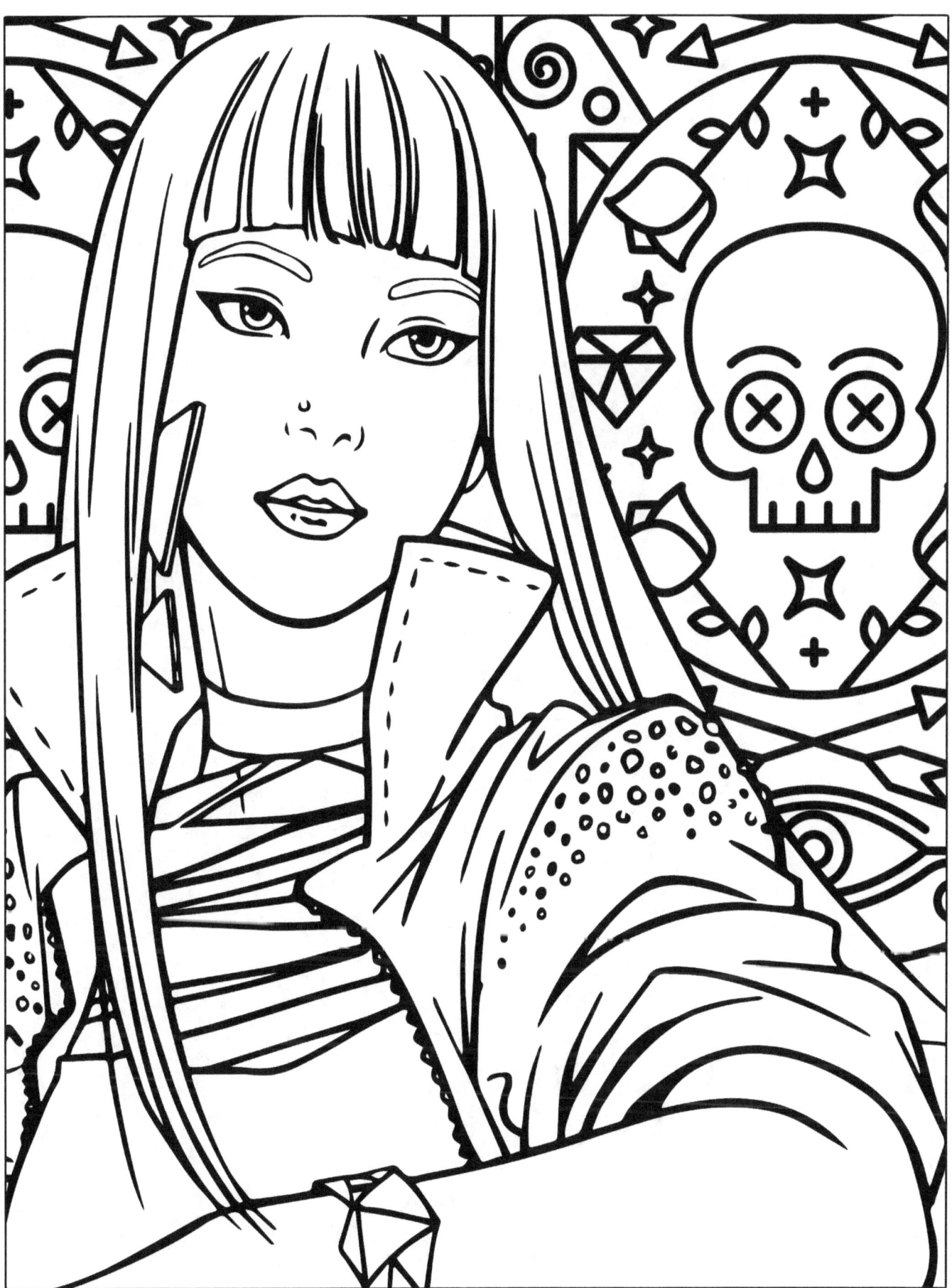

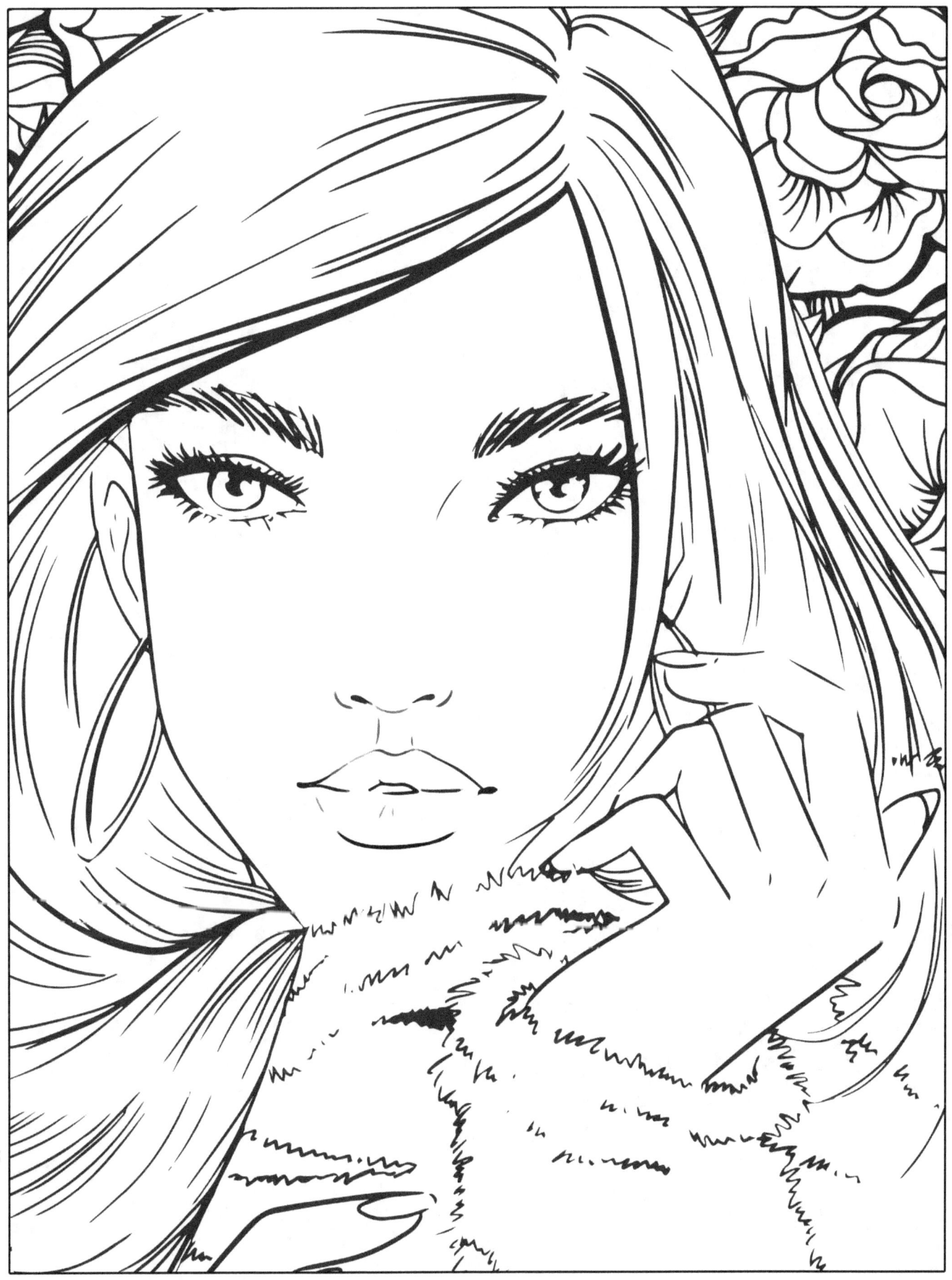

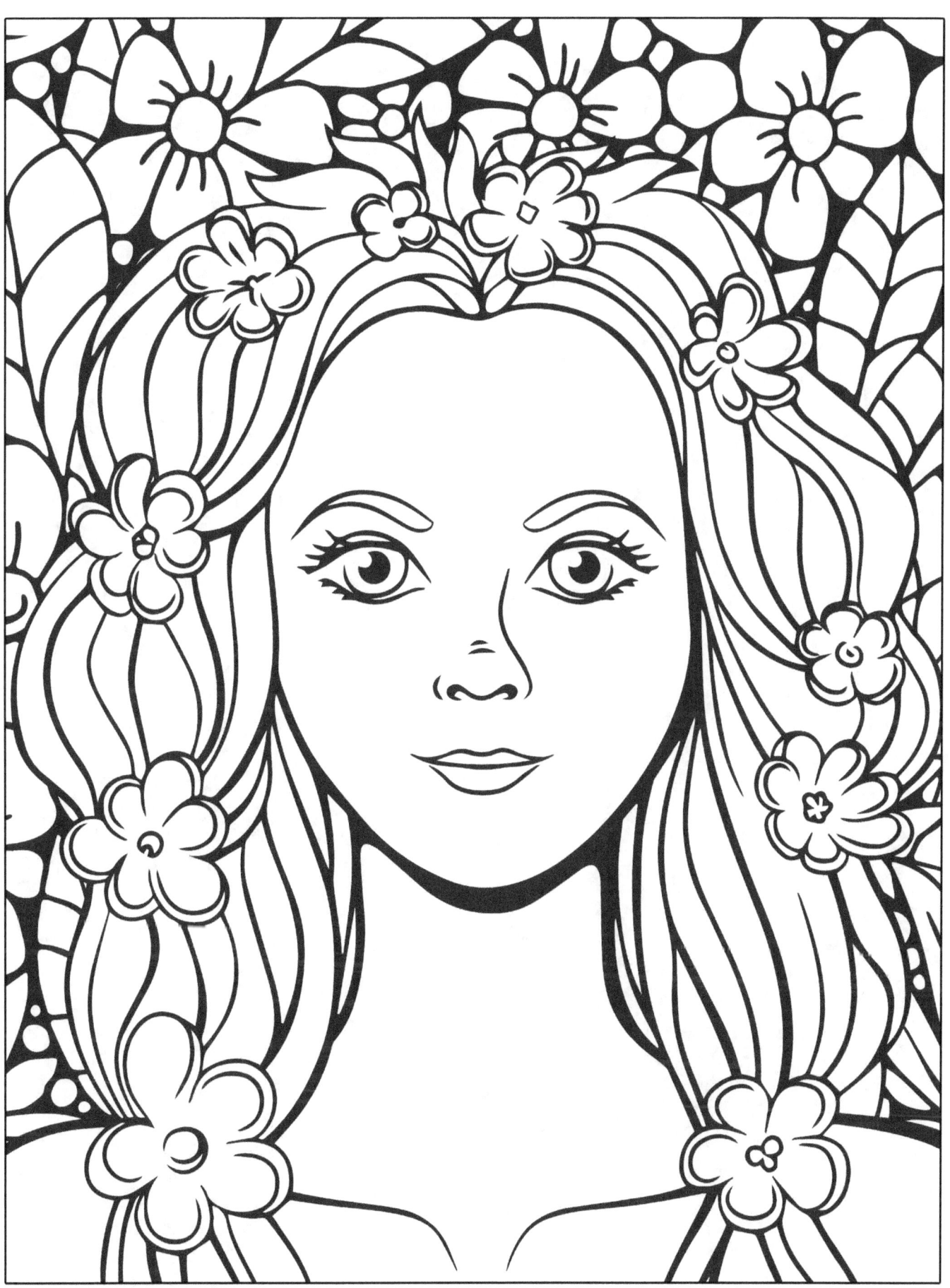

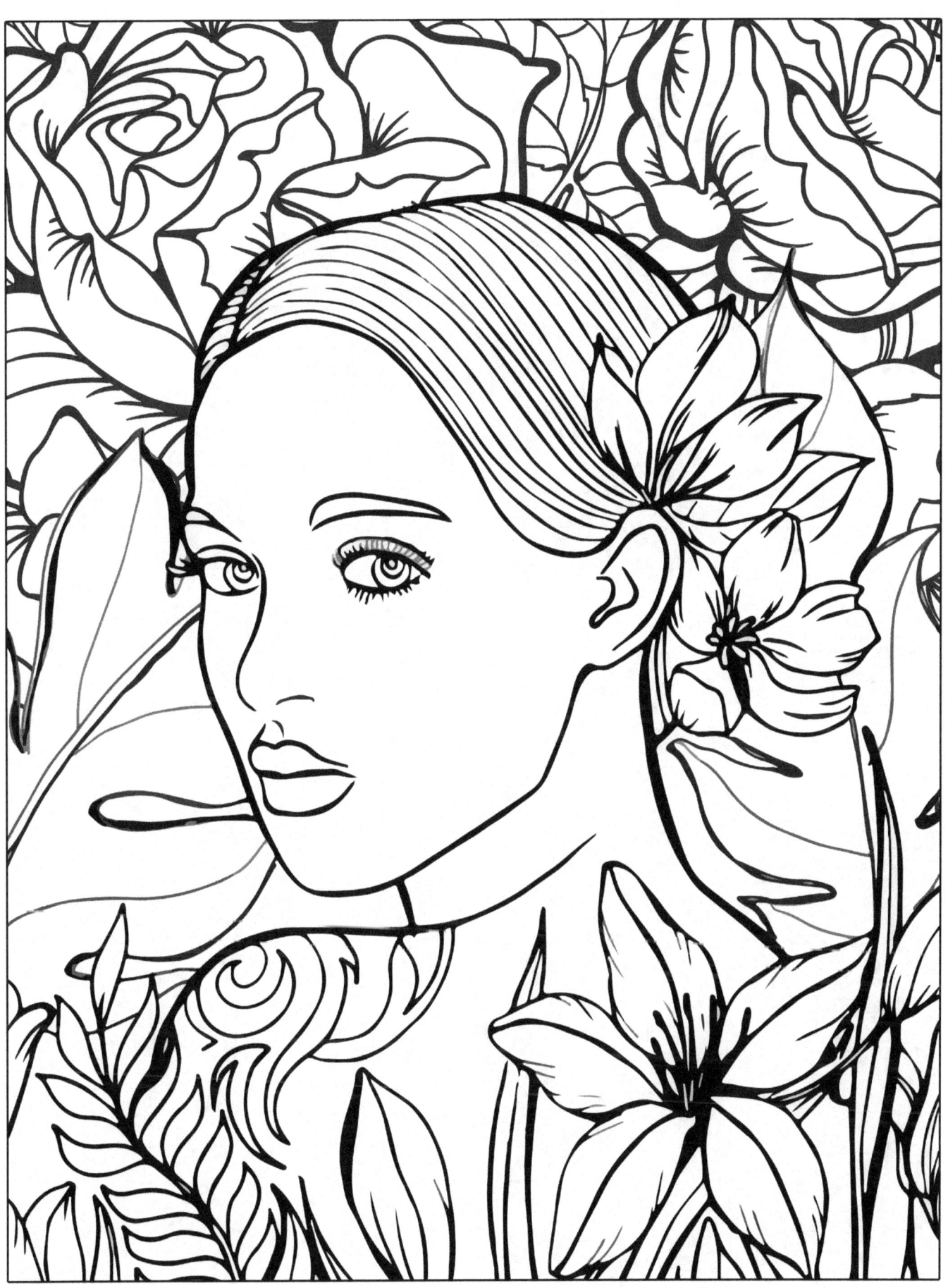

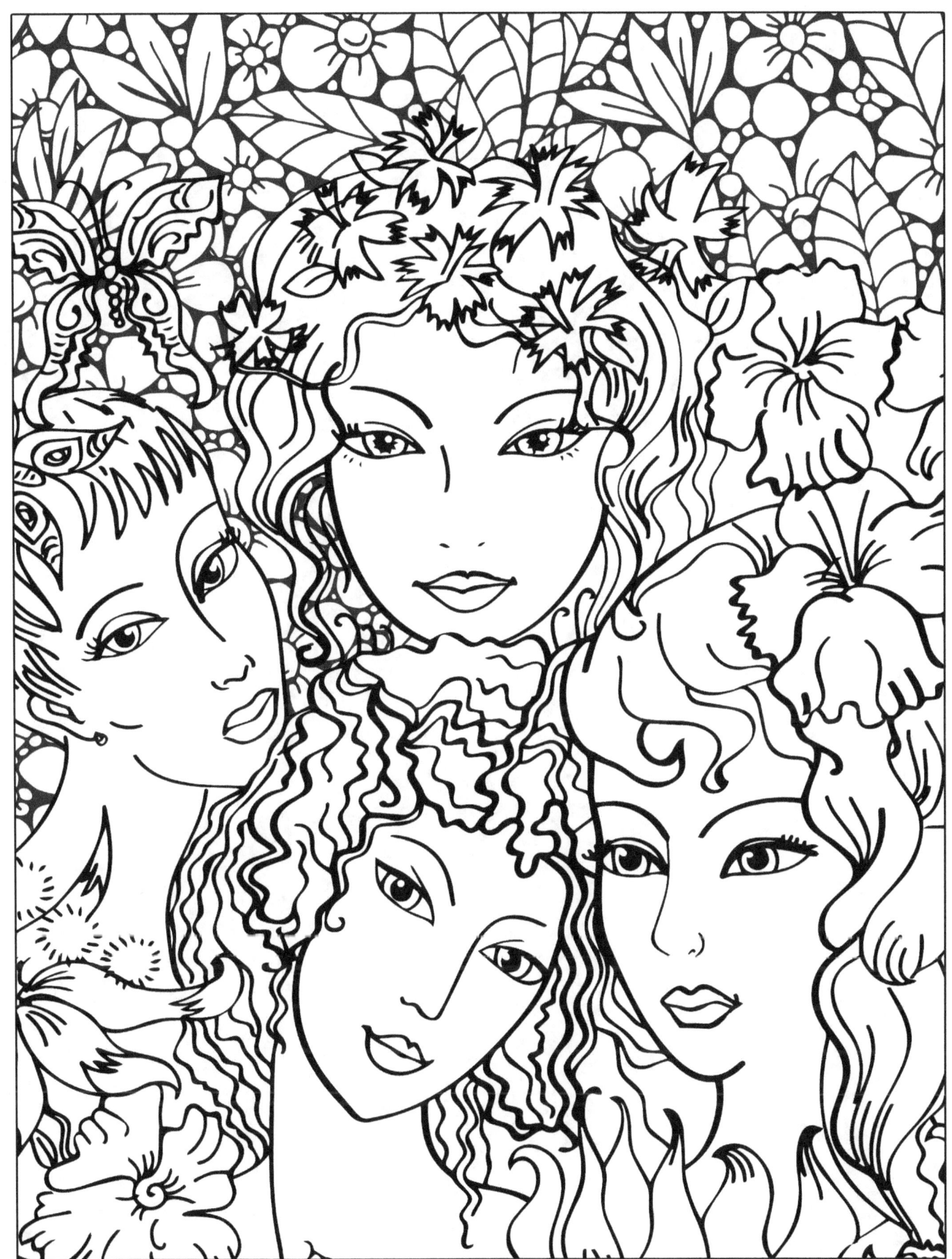

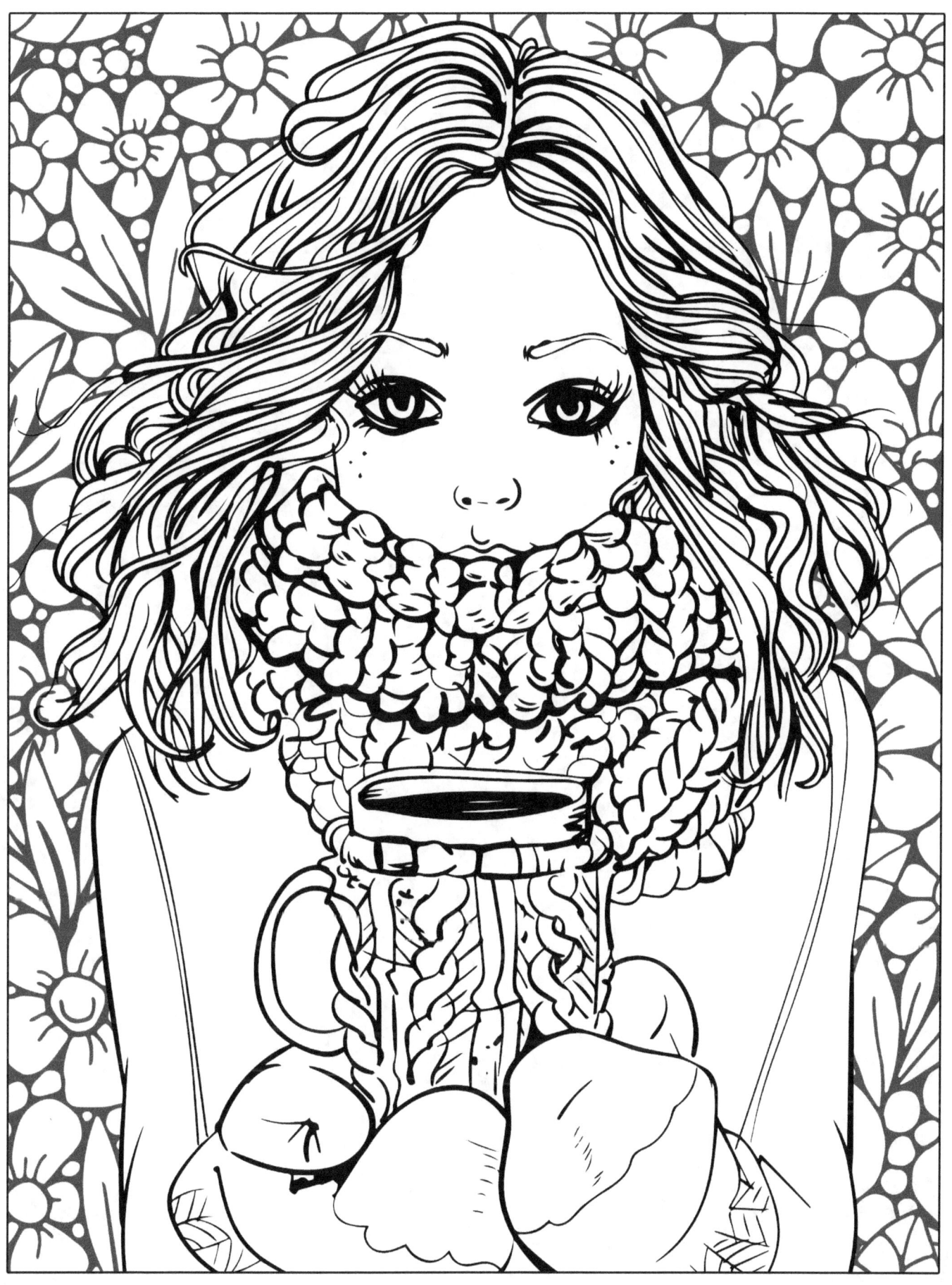

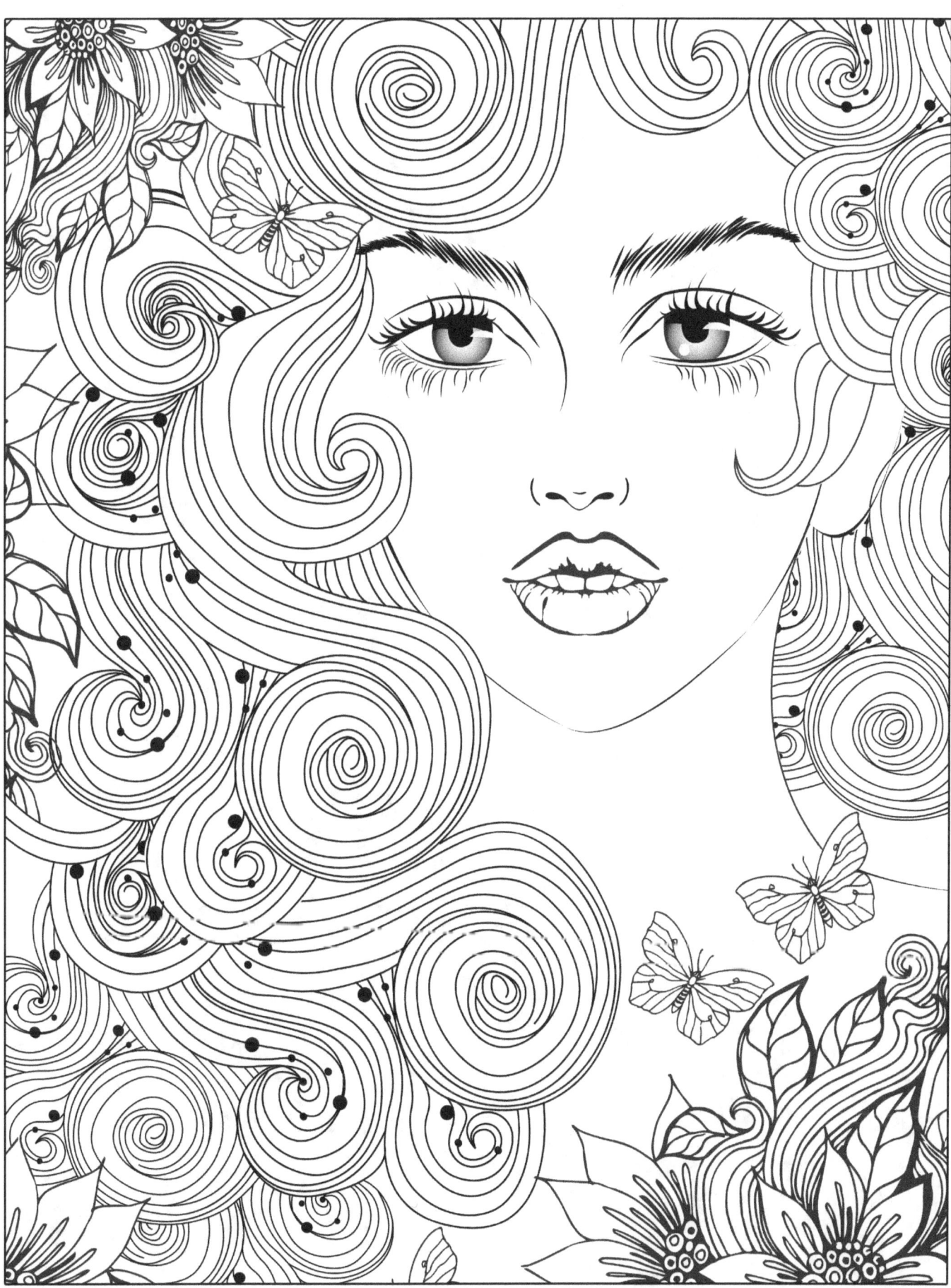

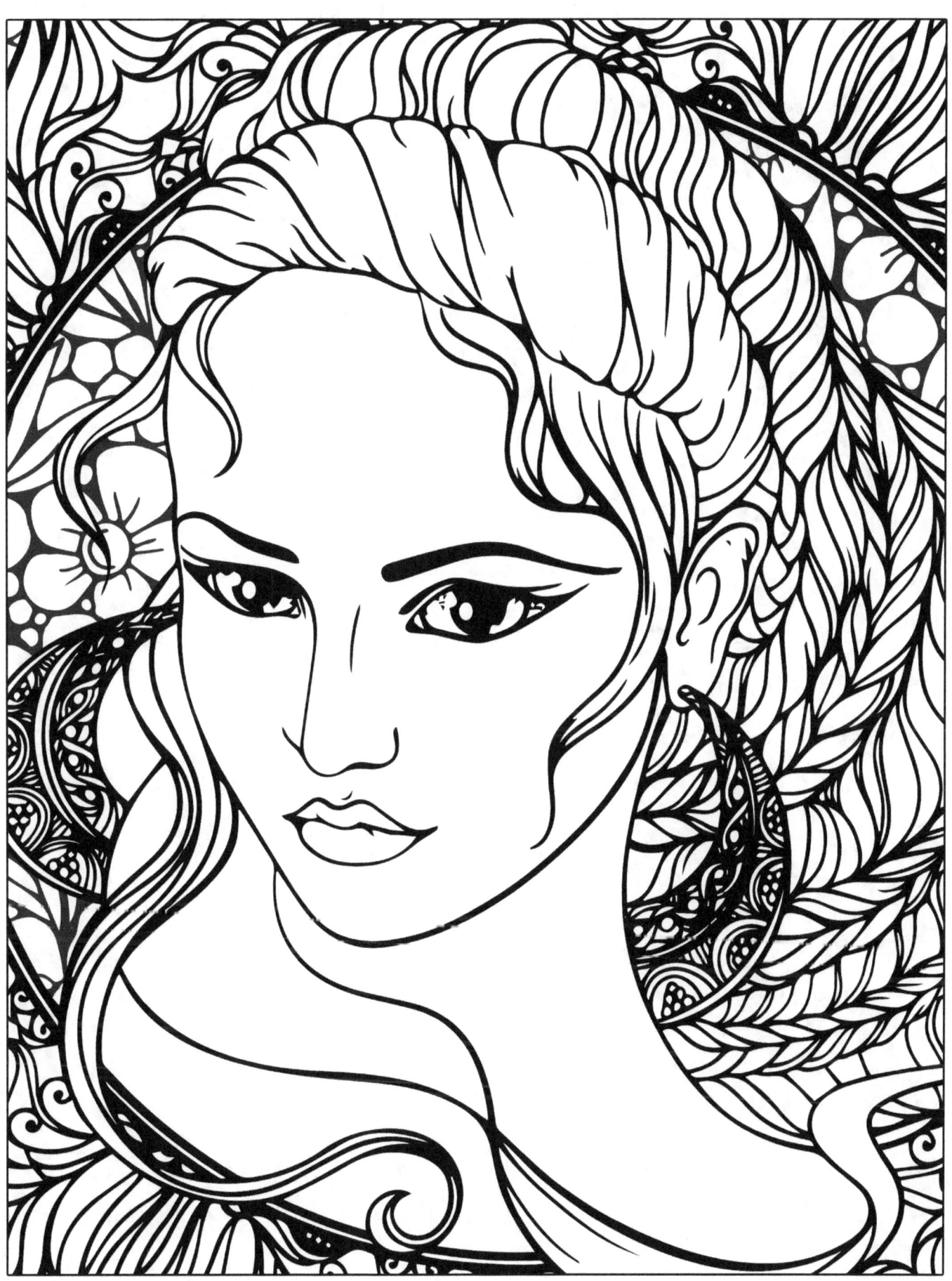

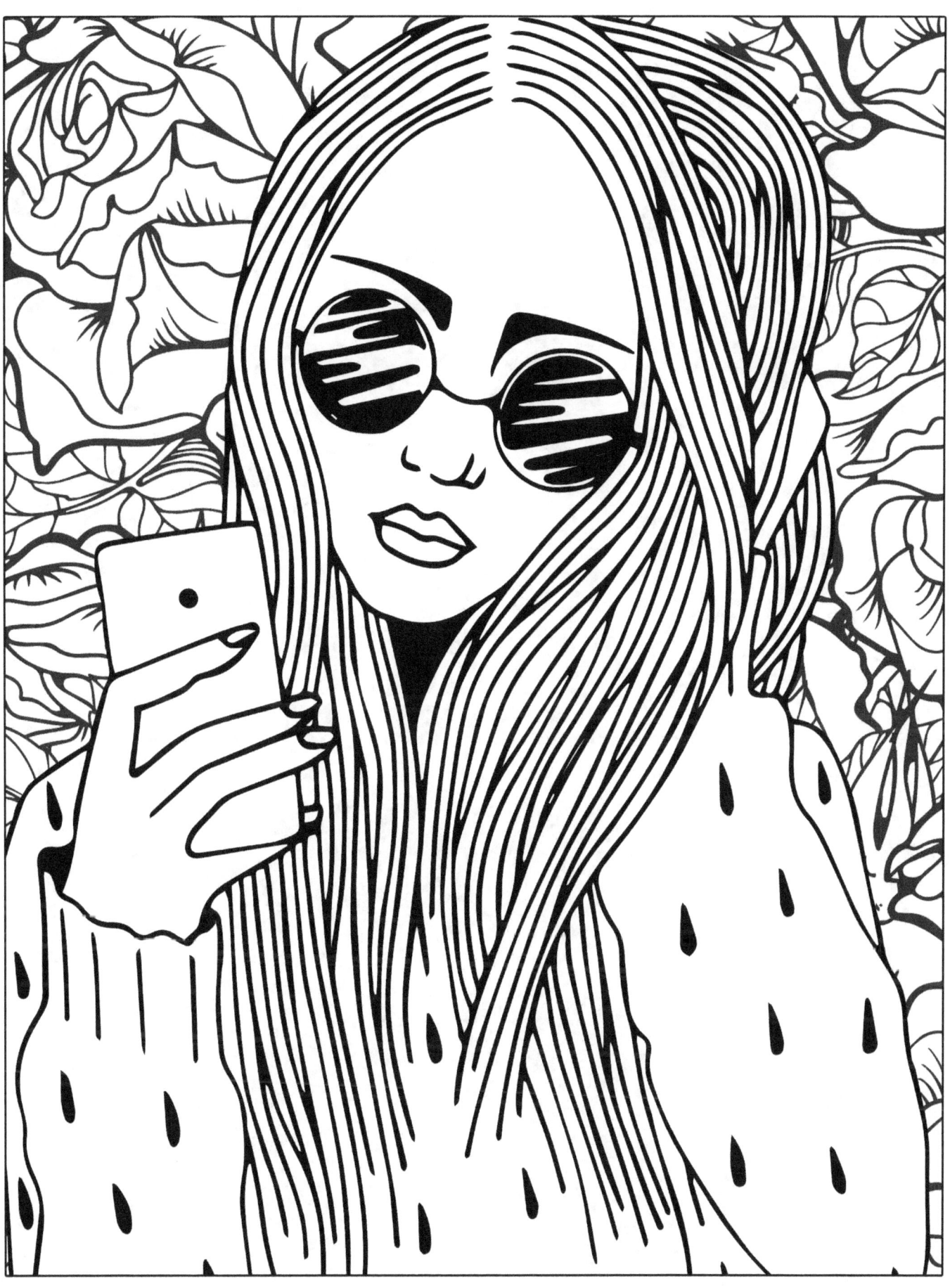

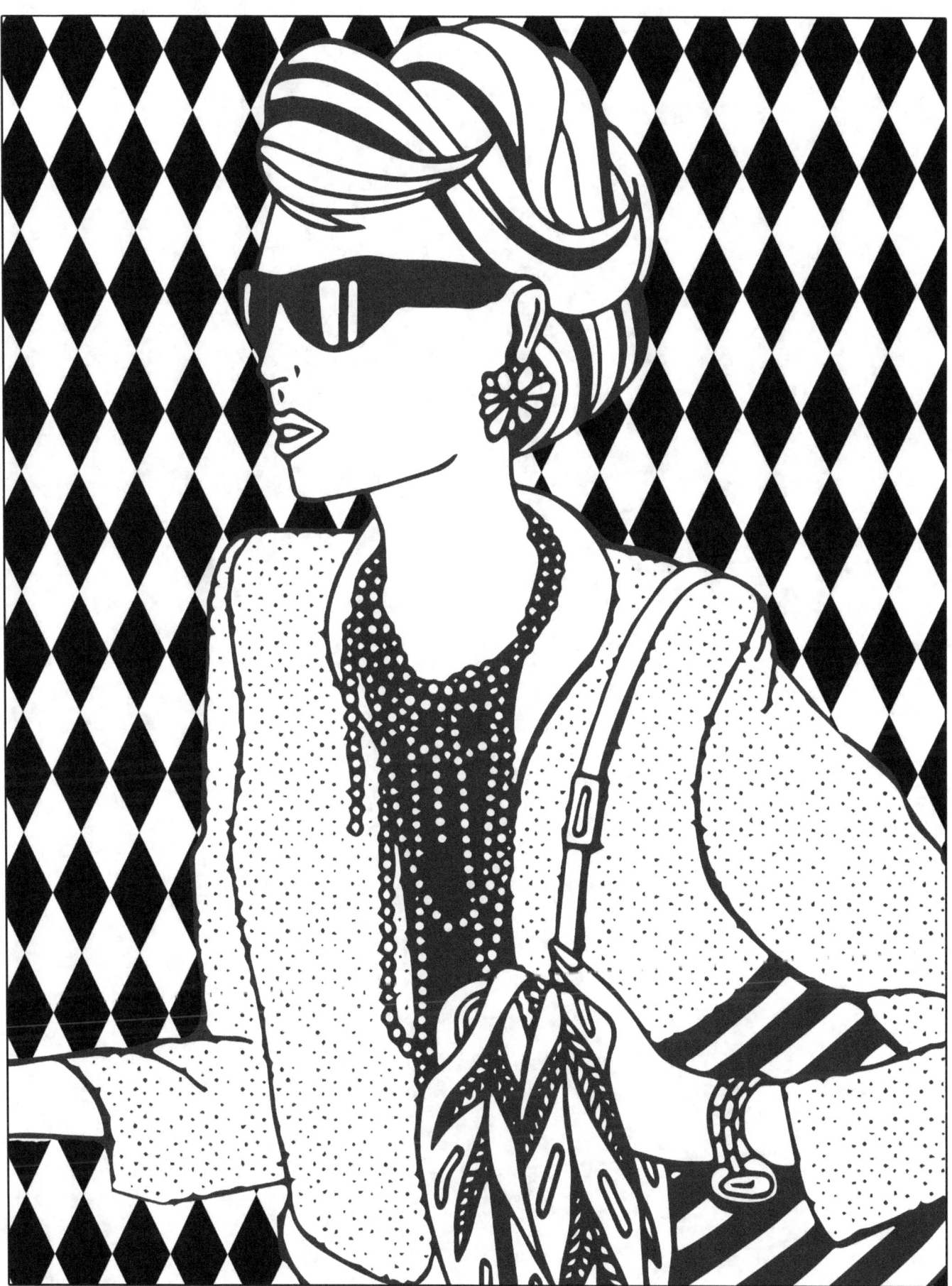

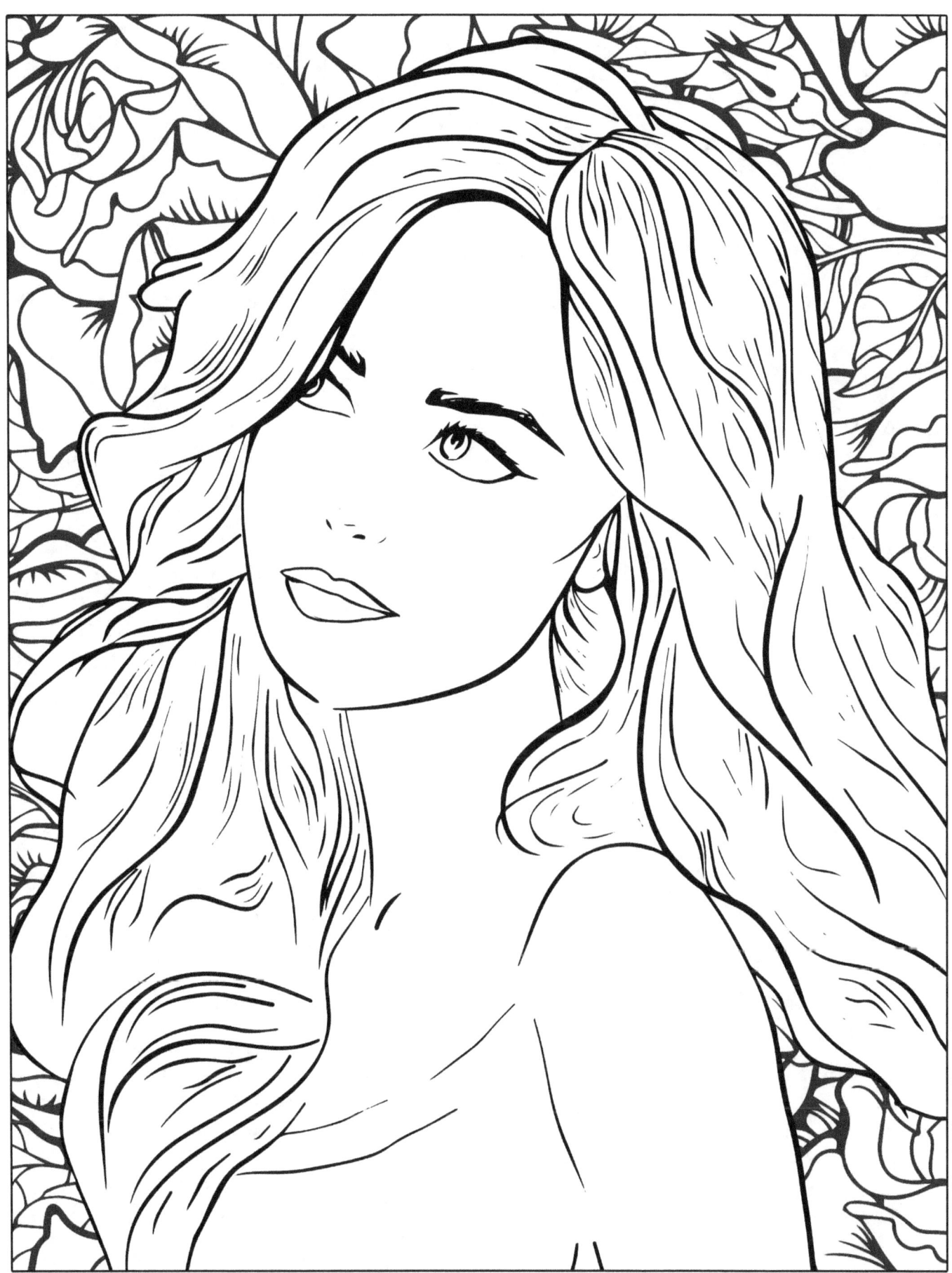

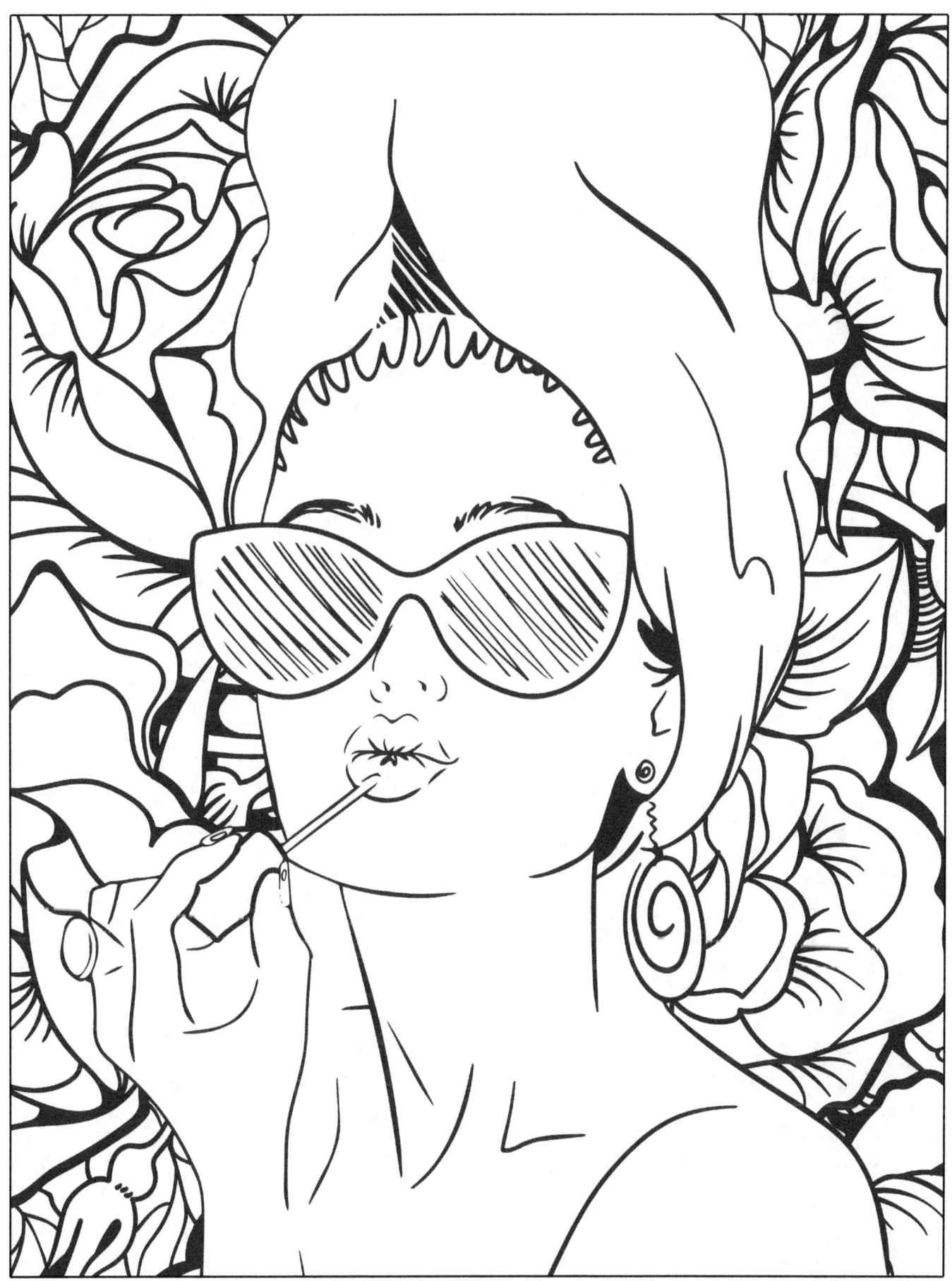

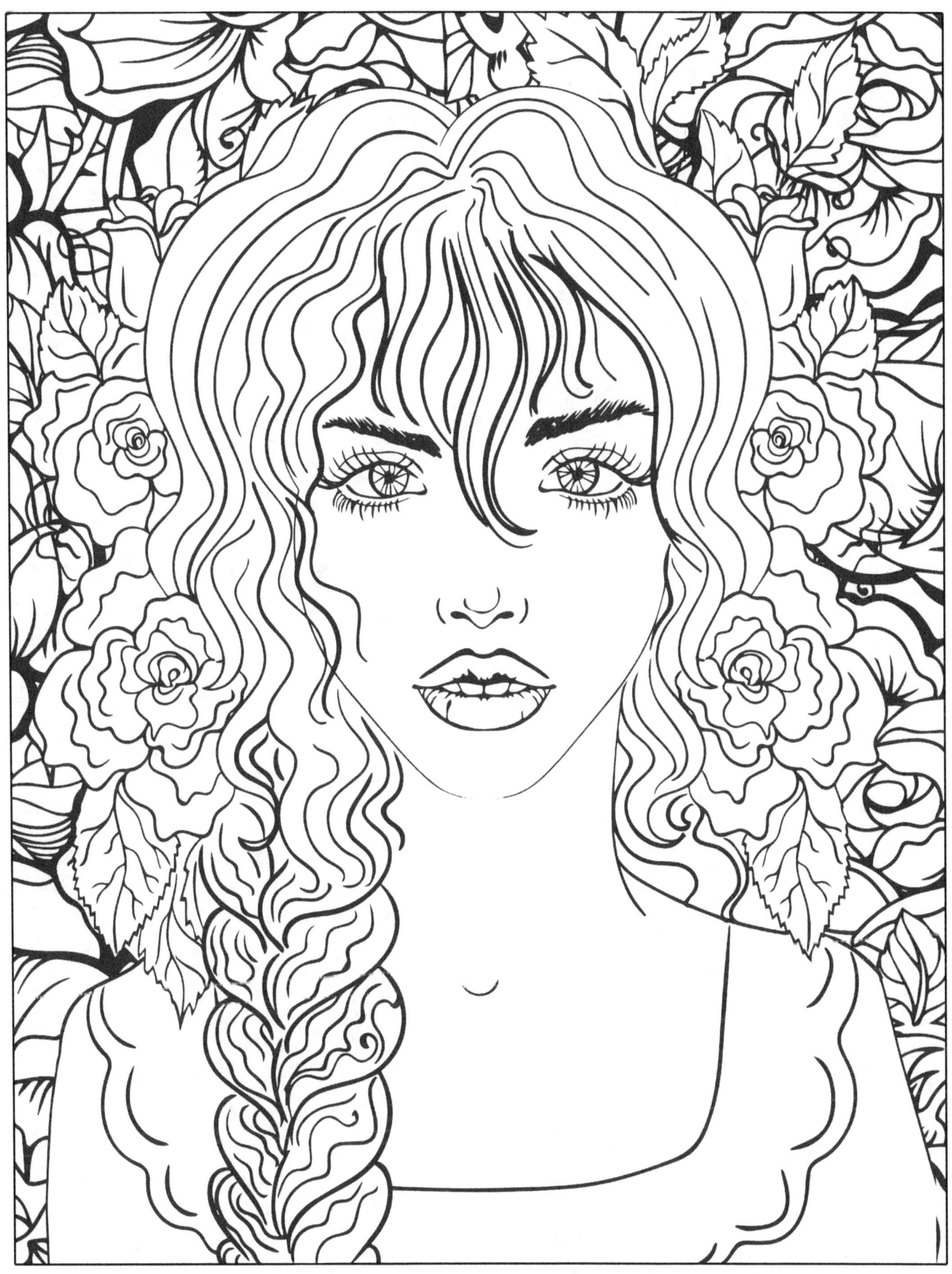

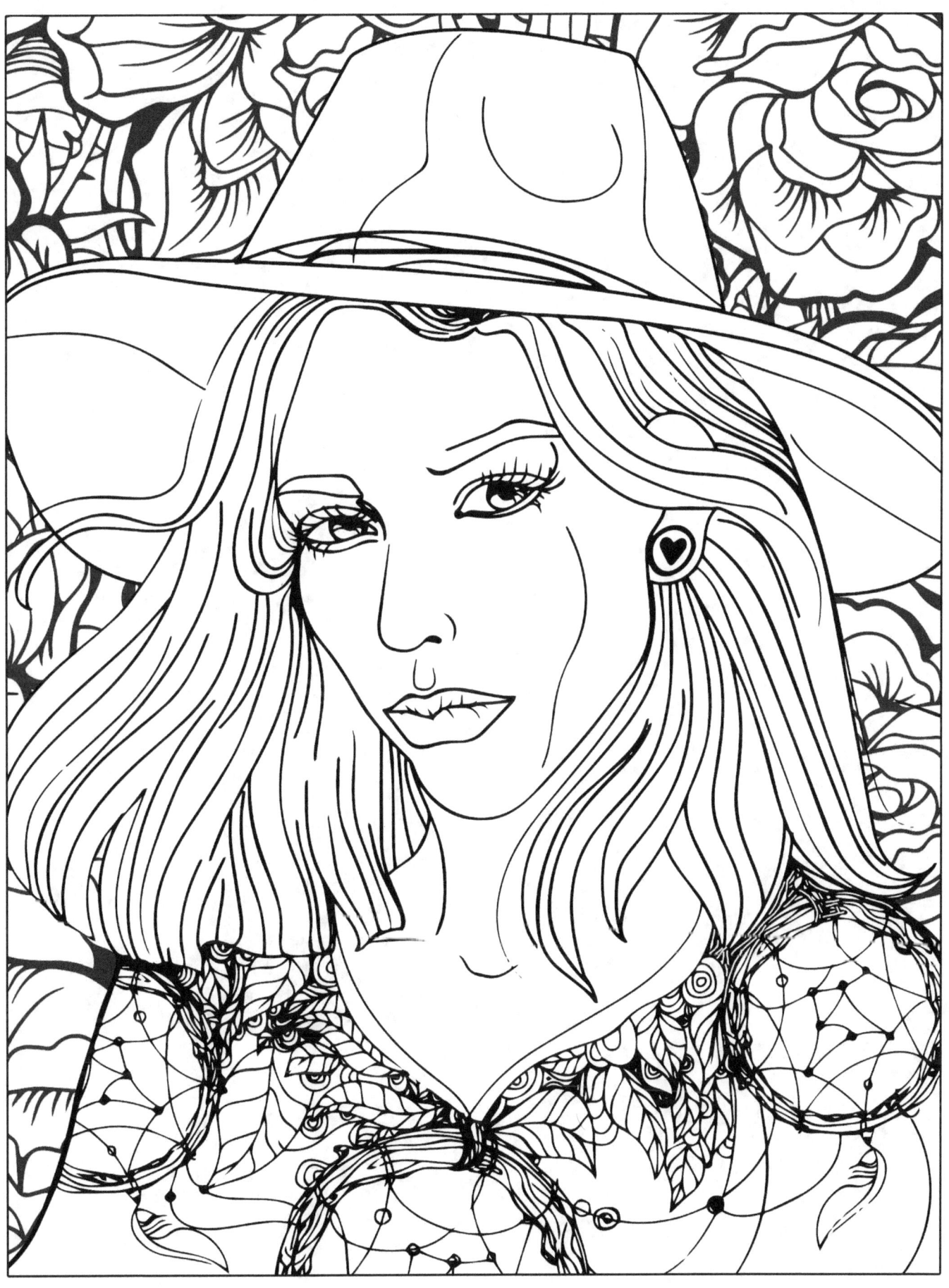

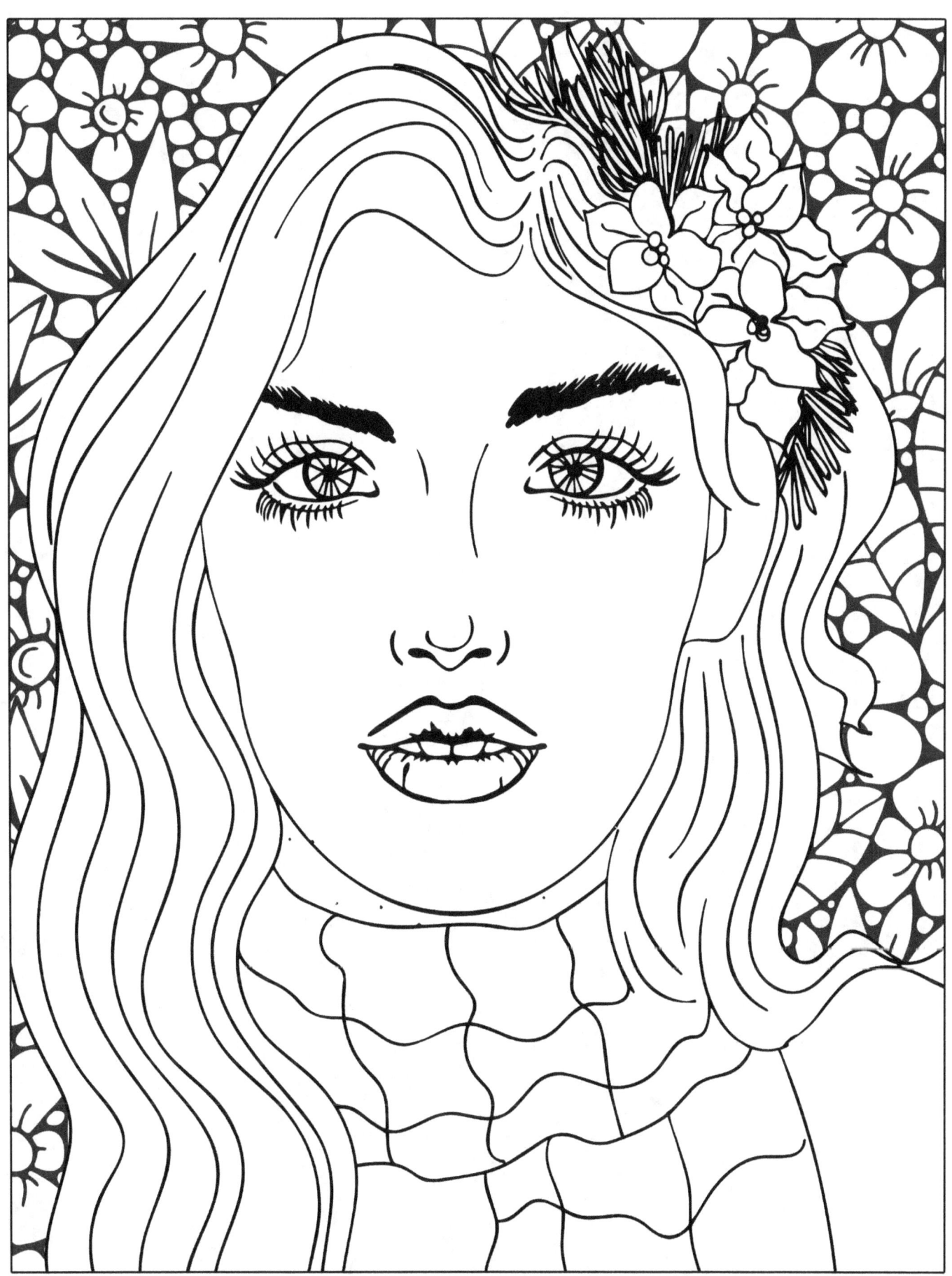

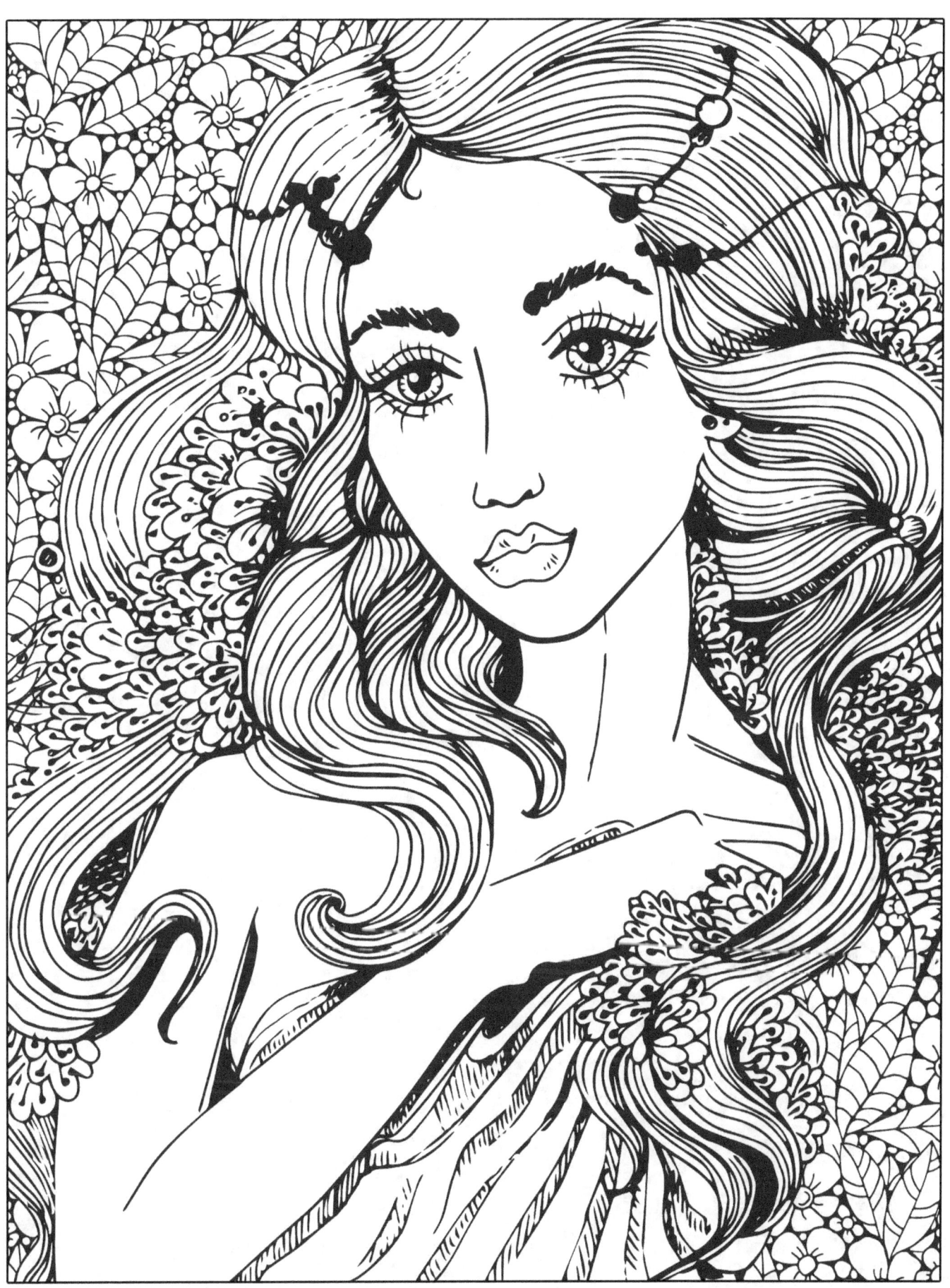

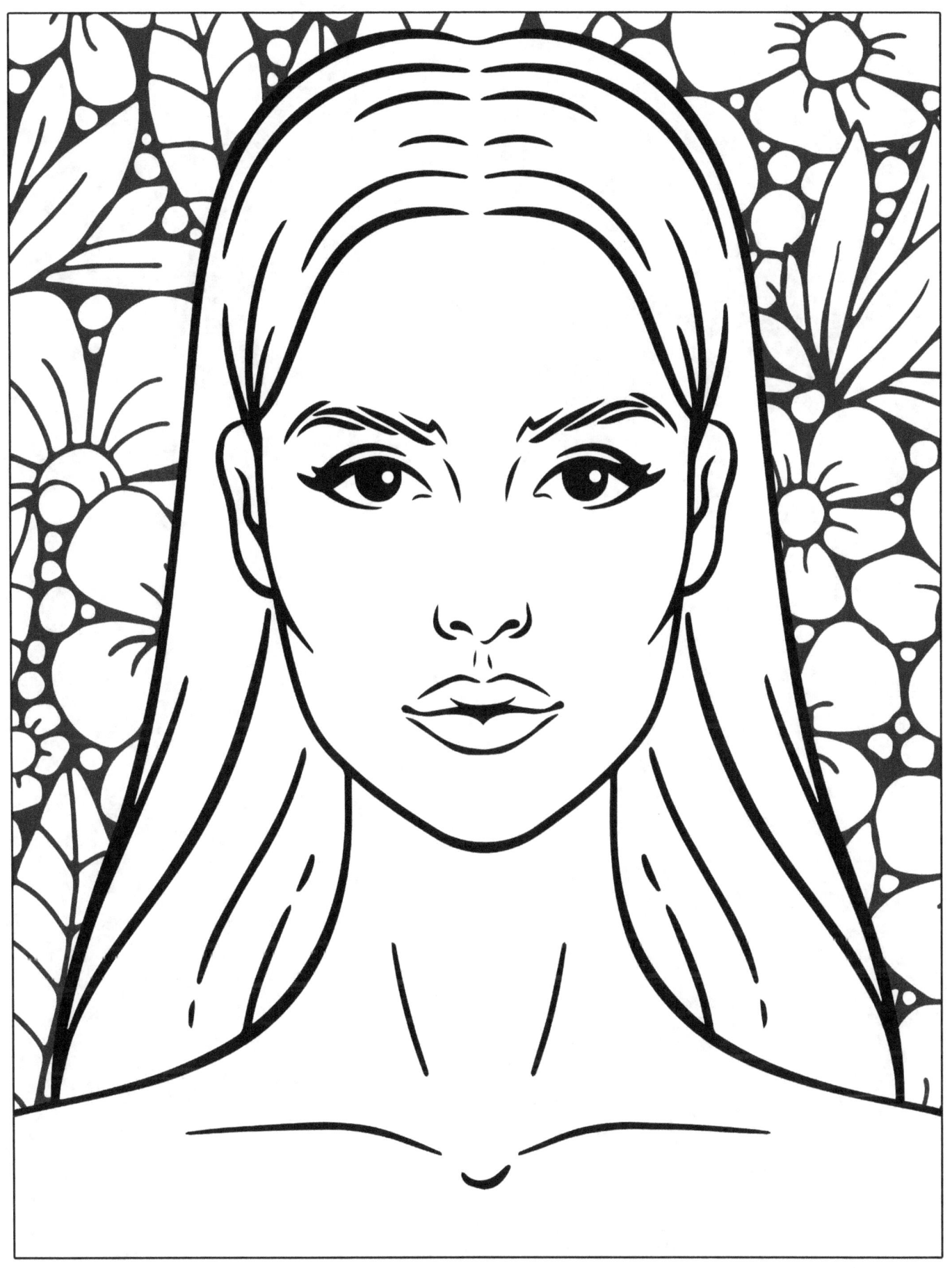

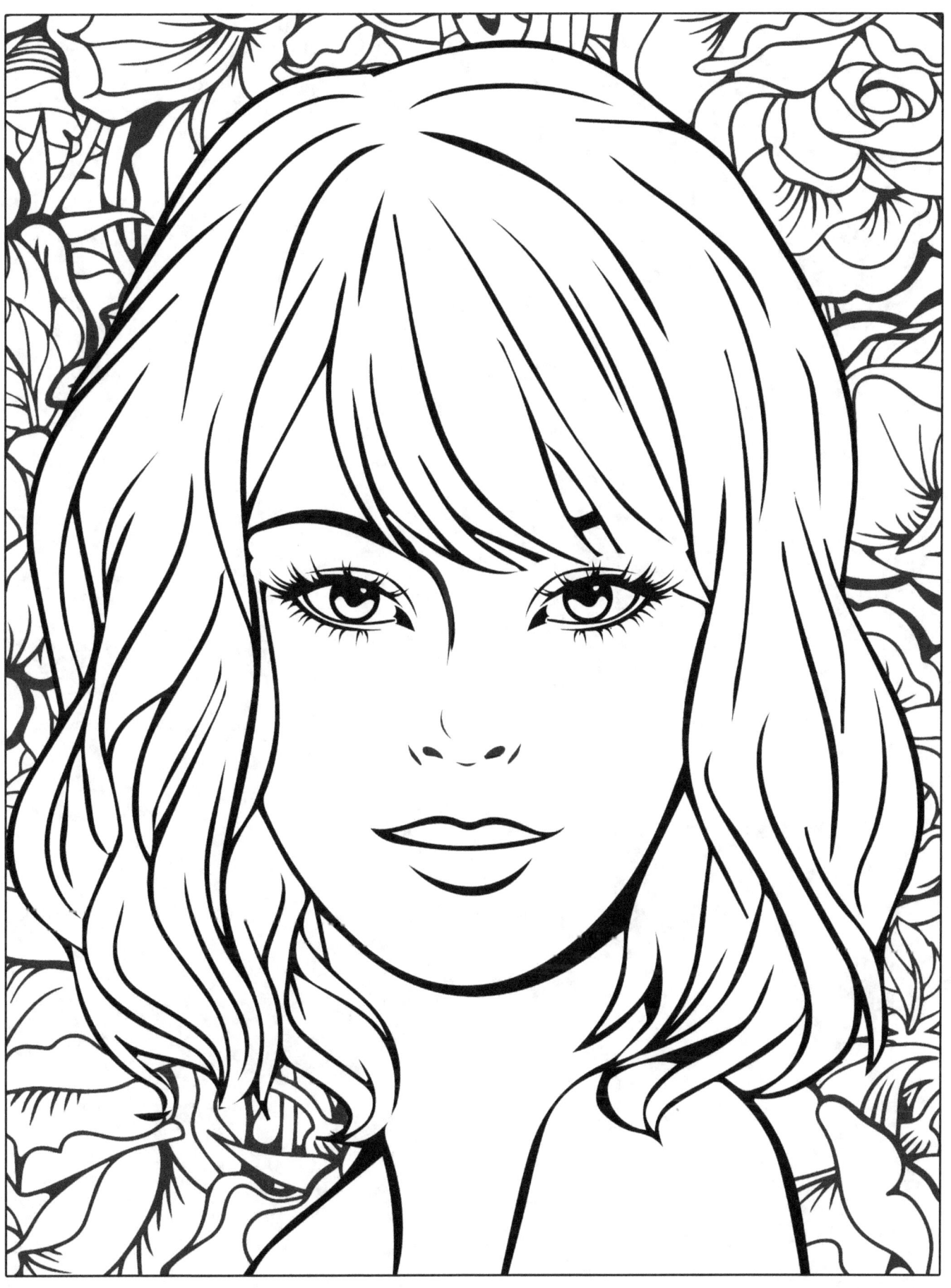

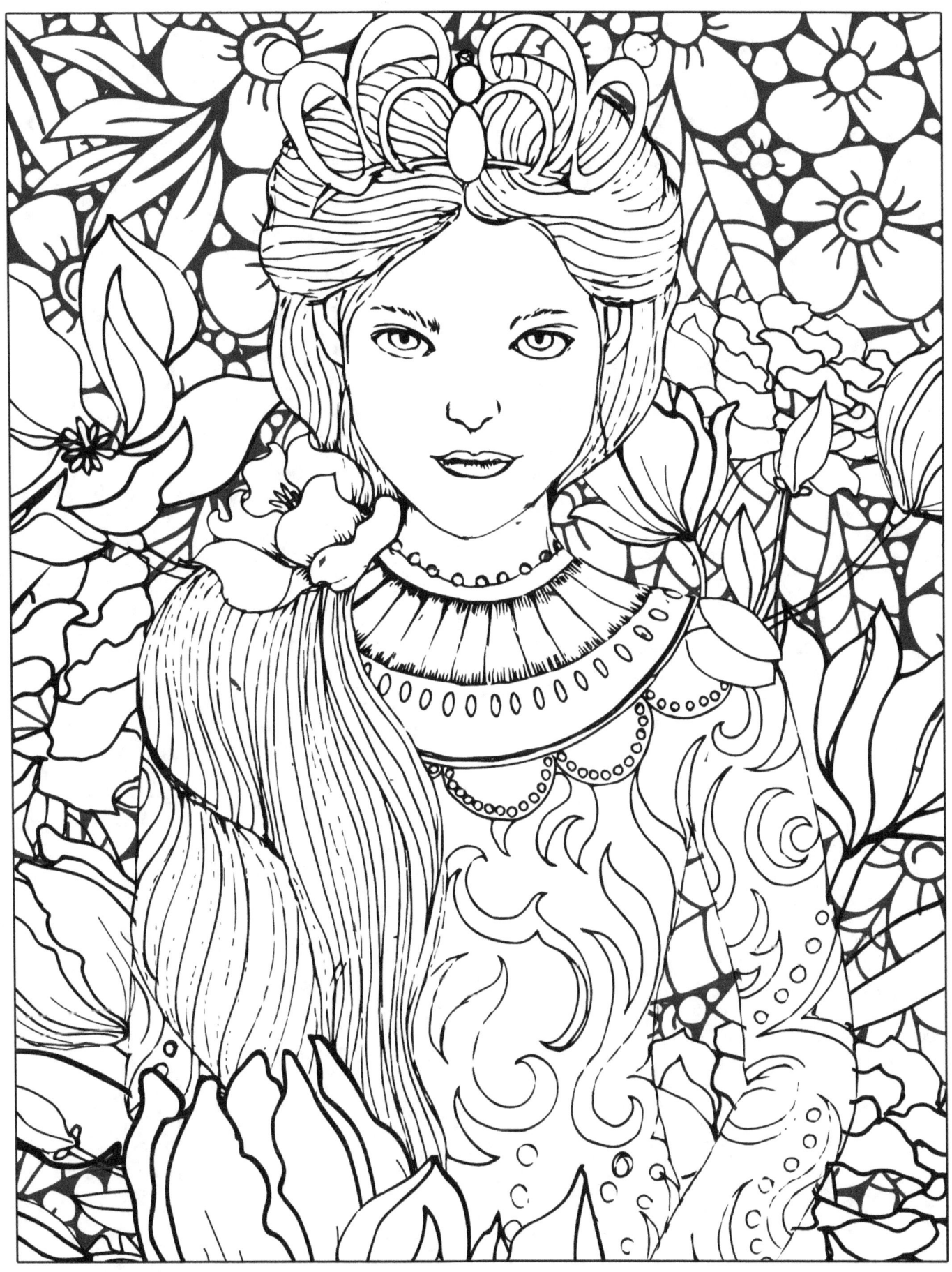

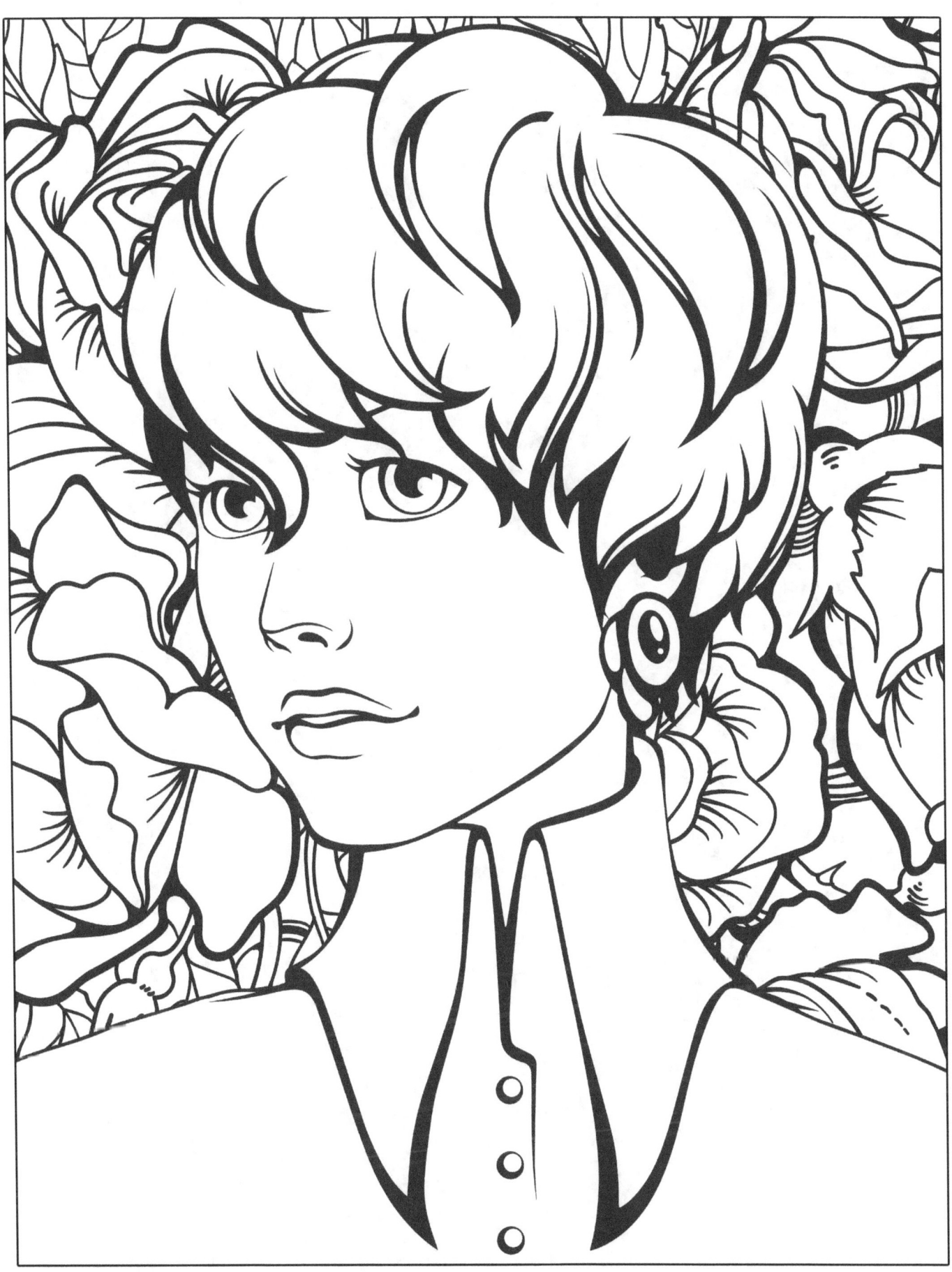

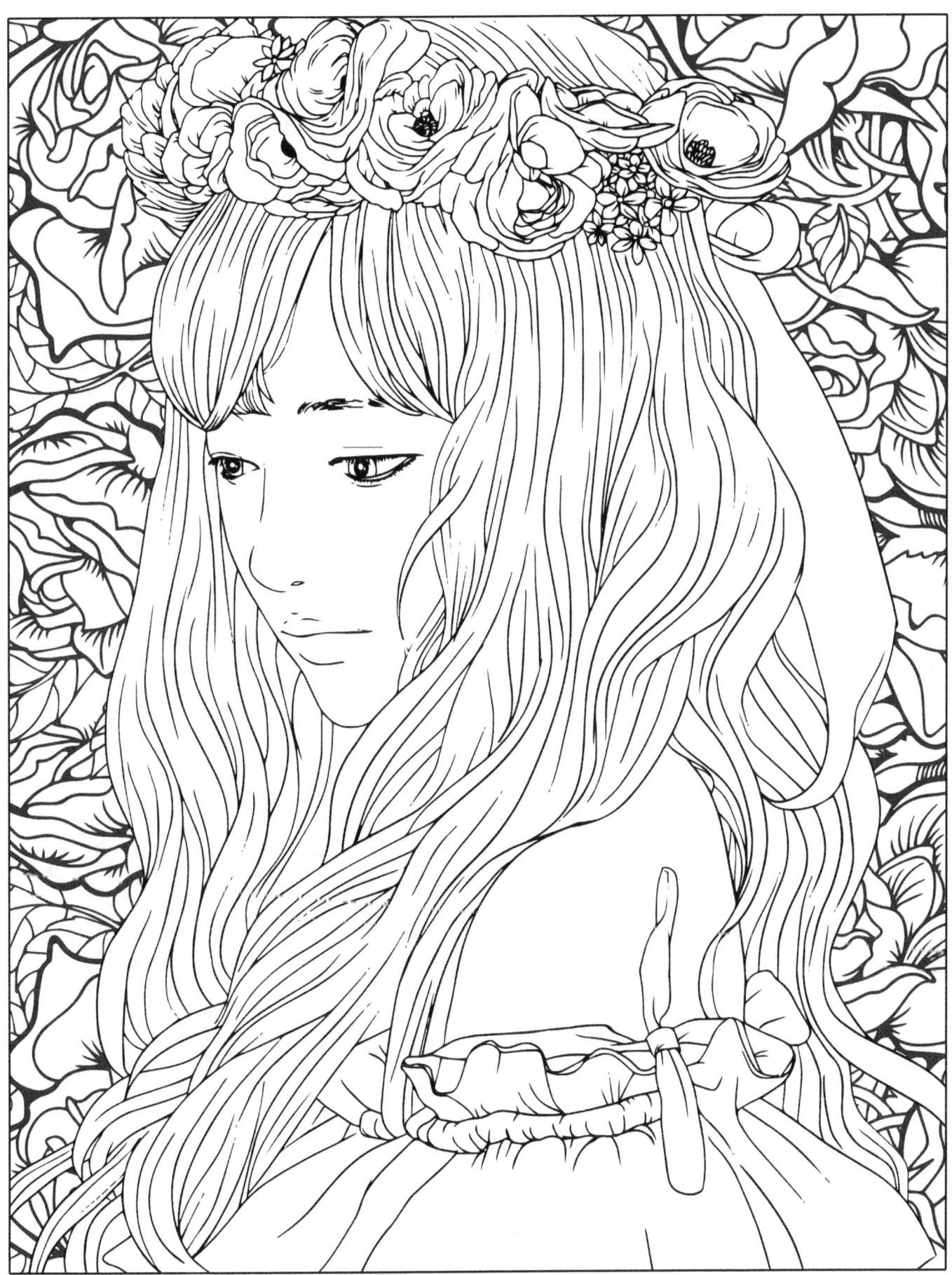

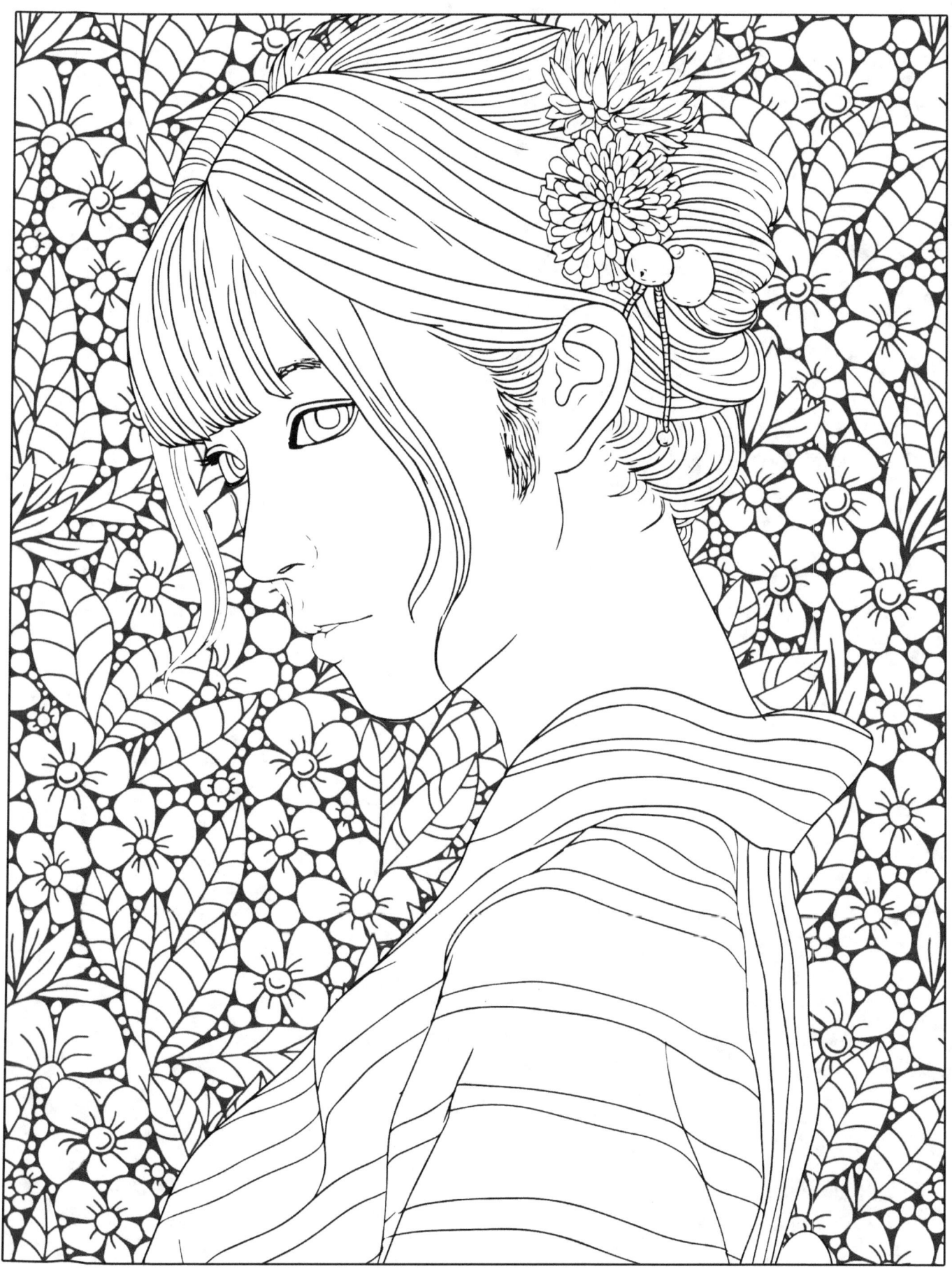

www.ingramcontent.com/pod-product-compliance
Lightning Source LLC
Chambersburg PA
CBHW080555220526
45466CB00010B/3152